No Regrets

No Regrets

THE BEST, WORST, AND MOST #$%*ING
RIDICULOUS TATTOOS EVER

by Aviva Yael and P. M. Chen

Foreword by David Cross

GRAND CENTRAL
PUBLISHING

NEW YORK BOSTON

Grand Central Publishing
Hachette Book Group USA
237 Park Avenue
New York, NY 10017

Visit our Web site at www.HachetteBookGroupUSA.com.

Printed in Canada

First Edition: May 2008
10 9 8 7 6 5 4 3 2 1

Grand Central Publishing is a division of Hachette Book Group USA, Inc.
The Grand Central Publishing name and logo is a trademark of
Hachette Book Group USA, Inc.

Library of Congress Control Number: 2007938195

Book design and text composition by Mada Design, Inc.

I want to dedicate this book to my family. I love you guys and I'm sorry that you raised such a potty mouth.

—Aviva Yael

To Juju!

—P.M. Chen

Acknowledgments

The authors want to thank our amazing editor, Ben Greenberg, Robin Cameron for the cover art, Camille Finefrock for her research, and our super agent, Elisabeth Weed.

Aviva:

Thank you to everyone who contributed to this book, even if your tattoos didn't make it into the finals. Thank you to Tasha, Justin, Liz, Jen "Jibs" Baca, Jeremiah, the Cross family, and The Virgins.

P.M. Chen:

Hi to Hiro, Earl, LTR, Yancey, Charles, Hebs, Tai, Claudia, Walker, Ben, Gav, Yao & Lisa, Jamie, Stone, Hecker, Rothman, Diner Crew, Roosevelt Island and New Orleans.

Foreword

By David Cross

Growing up I had always thought of tattoos as merely
representing the idea itself. That having a tattoo simply
said, "I'm the kind of person that would have a tattoo."
That may have applied to the standard prison or military
tattoo, but somewhere down the line tattoos stopped being
the sole province of the badass and seamlessly slid over to
the propriety of the soft, sensitive, malnourished hipster.
My guess? The unsolicited rockabilly/punkabilly revival
had a hand in it. Those selfish fuckers. When the hip and
affectedly unaffected get a hold of something that belongs
culturally to another group, excitement abounds as they then
excitedly co-opt it and an open display of competition is set
in motion. That's half the point of that shit anyway. The tacit
one-upmanship and approvals and disapprovals whispered
throughout the land.

This applies to tattoos as well, of course. We've seen the
evolution of the ugly, blurry monochromatic Navy anchor, or
the dark snakes-and-dagger-through-the-heart tattoo becoming
those now ubiquitous mysterious Chinese letters reading
"tranquility," or "boiling sea," or who knows what. But recently
the evolution has jumped almost tenfold from there. In only just
a few short years, we find that the "tribal tat" we were staring
at in every dance club on the Jersey Shore has now become a
twenty-color tableau of Bea Arthur giving Alex Trebek a hand-
job on the calf of the professional dog walker ahead of us in
line at the community garden's bike repair shop.

What? That isn't a tattoo yet? Hmmm, well as this book
goes to show, just give it time. Its inevitable day draws
near. That's what's so fascinating and unnerving about this
collection.

After leafing through it one is left with the question,
"Jesus Christ! What's next for these people?!" This book is
filled with mistakes, bad jokes, and delusions. Even given the
qualification of "irony," most of these tattoos are so horrific
that I predict a painful suicide will be the future for at least
a handful of their owners. What happens to the young man
who has a full-scale back tat of a smiling, beatific Adam Duritz
with the legend "Straight Edge" above, when he realizes that

perhaps Ian Mackaye might have been the better choice for something so bold and permanent? And Bob Barker? Who the fuck is gonna remember that guy in ten years? And then you have to explain that he was an unremarkable game show host? And then you have to explain that you thought it was funny (at the time) and then you have to revert to roofies if you ever want to get laid again? Oh well, whether they know it or not, or whether it was intentional or not, these brave people collected herein have done us a tremendous service. They have entertained us and filled our lives with song!*

* "Unreal Is Here," by Chavez

Author Note

When this book was conceived in 2005, I had a career in fashion working at *Vice* magazine, where I picked up some much needed skills for expressing my distastes. You see, I'm from Northern California where it's taboo to say how you feel about anything unless it's dipped in purple and teal tie-dyed, crystal-hugging affirmations. Ew. As you can imagine, finding people who hate the same things as you is sort of crucial to living in New York, and I'd happily found that at *Vice*. The interoffice e-mail humor wasn't like the amateur stuff that banters about in your office. No corny jokes about dating or George Bush or sarcastic checklists. No, *Vice* was and still is one big riff factory. And it's also where I learned how to stop being such a pussy, which ultimately led me to start embracing that which I don't understand. For instance, tattoos.

When I started this venture, I didn't get the whole tattoo thing. I'd seen some cool ones, but truth be told, they just weren't for me. I was jaded over a decision I'd made at age nineteen to pierce my navel (*blech*), and I always thought that people who were brave enough to get tattoos would someday feel the way I felt about my little deal-breaker — but they wouldn't be able to remove their ideas like I did. I couldn't deal with my own little regret, much less add a new one to my body. That was a long time ago. I've since changed my opinion about tattoos, the artists, and the entire culture, but I'll get to that in a minute.

It was Christmastime in New York, and a bunch of my pals were having a pint at one of my favorite bars. We started talking about the worst dates we've ever had.

One friend told us how he had met some girl on MySpace and that they had started an e-mail flirtation for a few weeks that led to a date. He asked her to dinner one night, but she told him she had to go to L.A. for work and would call him when she returned. Cut to three days later: She called him while the plane was still pulling into the gate to hang out that night (yikes). When he showed up at her place he was welcomed by a roomful of burnouts sitting on her couch glaring at him like he was that kid from *Mask*. No hellos, just stares. She offered him a drink and within twenty minutes

started taking "sexy pictures" of them together (uncomfortable much?). When she went into the kitchen to fix another drink, he scrolled backward through the pictures only to discover that she had been performing lewd acts on a very happy young actor. The photos were taken by a third party. Sweet!

Obviously, my friend had already decided at this point that she was the worst date and possibly the least appealing woman he had ever gone out with, but he wanted to be polite so he let her take him to a place for a drink and dancing. They ended up at a now defunct bar known for its nefarious parties, where she proceeded to show him her tattoos. First she took off her shoes and poked her toes through her fishnets (nice visual) to reveal the lucky charms on all ten toes. Then she turned her back to him, lifted her shirt, and revealed a lower back tattoo of an alien sitting on a mushroom smoking a hookah. Needless to say he never saw her again.

After hearing this story, P.M. turned to me and said, "Someone should really write a book of the worst tattoos ever." And so the book was born. Many, many tattoo conventions, road trips, tattoo shop visits, interviews, e-mails, and phone calls later we have what you see here, presented in all their glory.

However, this is not a book of the worst tattoos ever. I assure you that after looking at thousands — and I mean over ten thousand tattoos — these are not the worst. There is no book that could capture what we've seen. In fact, we found the BEST: the funniest, smartest, weirdest, most ridiculous, insane tattoos ever.

I love every single tattoo in this collection. With the exception of a very few (I'll let you decide which), we have collected some incredible compositions of clever ideas, skilled artistry, and just plain genius.

I really didn't expect to have so much fun working on this project. We've had so many laughs while making this and met many amazing people all over the country.

P.M. and I want to thank every person who was involved with the making of this book, from the tattoo artists to the donors and wearers of these tattoos. You guys rock, and we loved every minute of making this book. We also want our readers to know that all of the jokes in this book are in a good spirit, and that none of it is personal. We're just having fun. You guys have inspired me to get my own ridiculous tattoo. Currently, it's a choice between that moon-faced cheeseball from the McDonald's Mac Tonight commercials, and a Camaro 357 with the word "Bitchin'" aflame on the doors.

Enjoy!

—Aviva

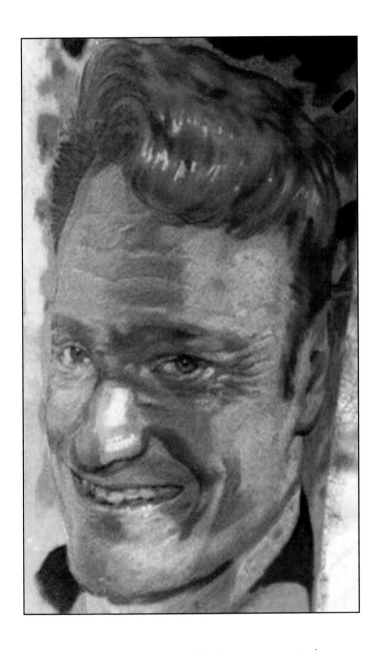

"Good evening America! We have a great show
for you tonight. First up, a book of the best,
worst, most fucking ridiculous tattoos ever.
Enjoy!"

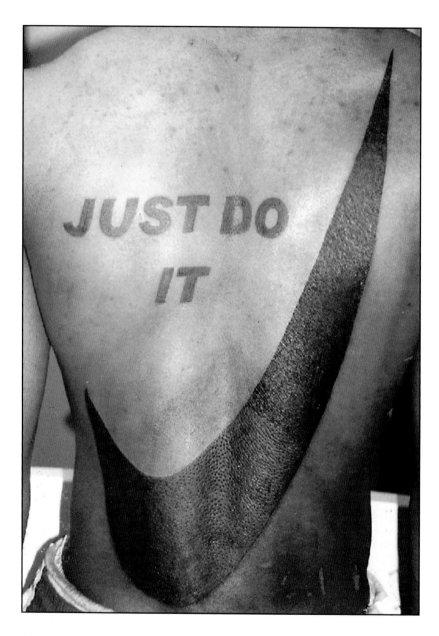

It's time for the marketing execs over at Nike to tone it down just a tad. Can we give them a little vacay and some chill pills please?

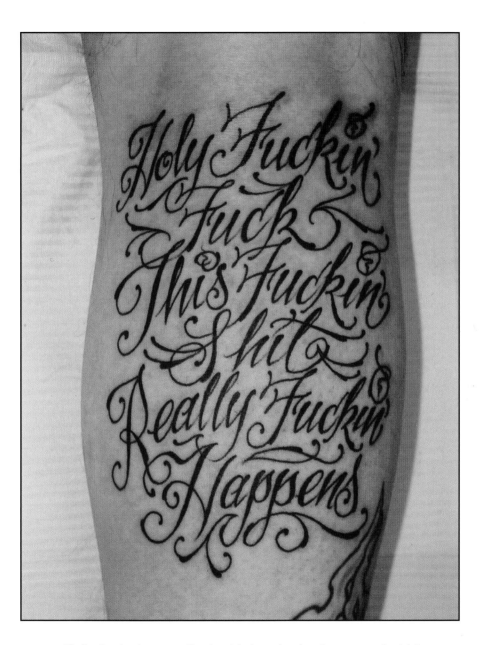

Holy fuck they really fuckin' make brains out of shit!

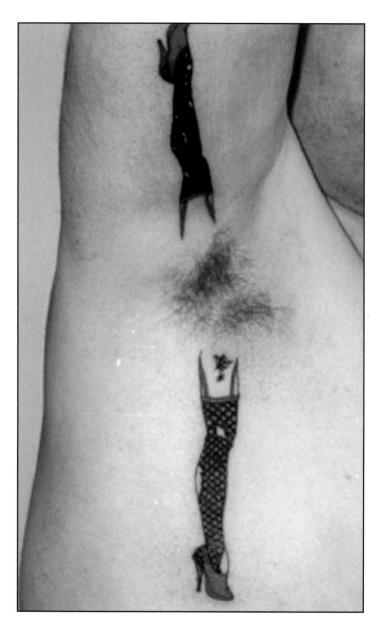

Hey, Eugene, haven't you heard that Brazilian
waxing has swept the nation?

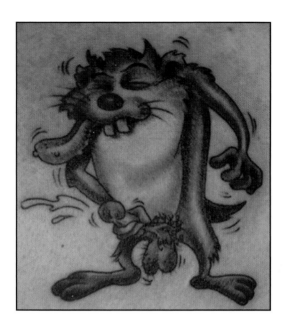

Masturbating Taz tattoo? Have you ever even SEEN a woman? Why not just get a tattoo of yourself never getting laid for the rest of your life?

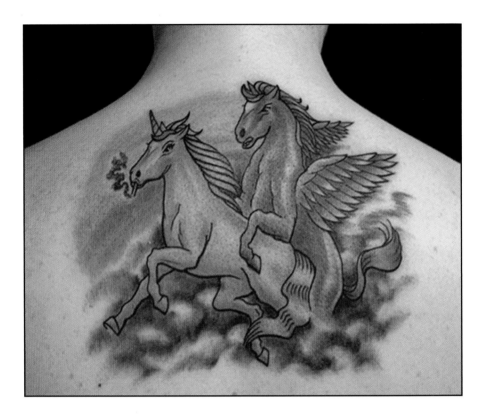

This is what happens when chicks die: We turn into magical pink unicorns who get blazed by our big strong Pegasus boyfriends on a cloud in the middle of a rainbow. Then we get to smoke afterward and nobody tells us it's a cliché.

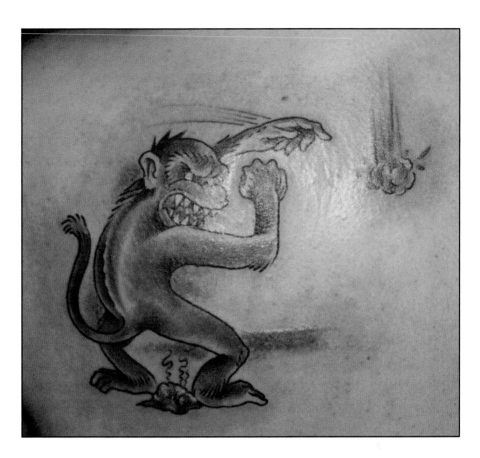

You know when you're at the bar with your girlfriends and you tell some drunken lurker you don't feel like dancing to "Brick House" and he calls you a bitch? This is what they look like when you bail.

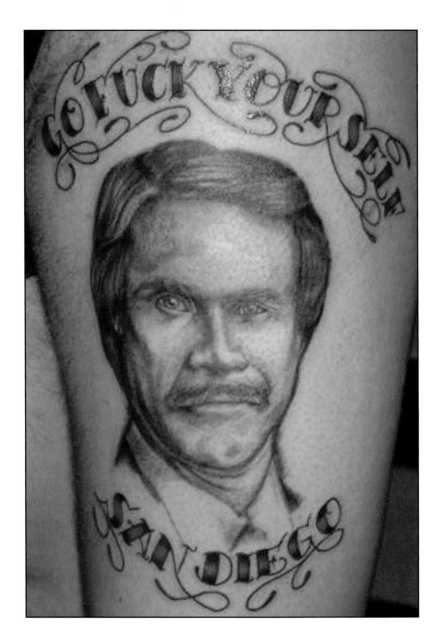

The owner of this tattoo has many leatherbound books and his apartment smells of rich mahogany.

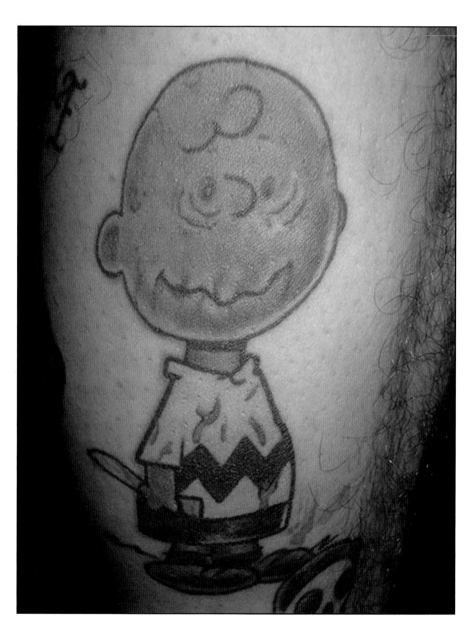

Sorry, Lucy, that's for fifty-eight years of pulling the football away, you little bitch.

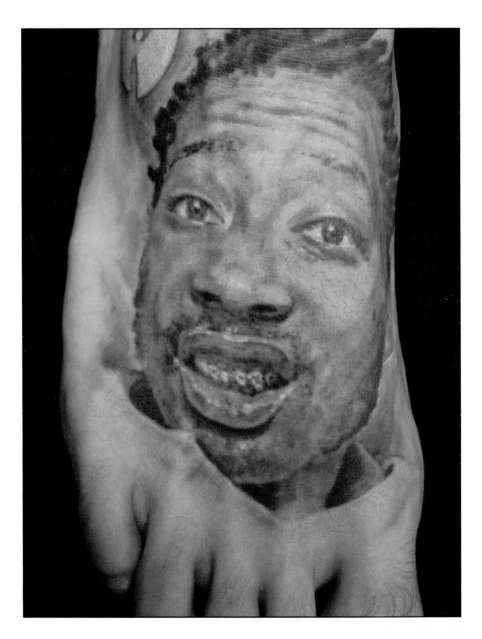

R.I.P. Ol' Dirty Foot.

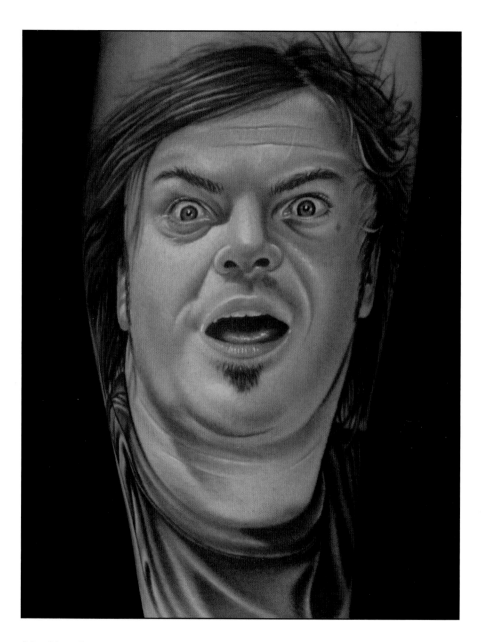

Oh. My. God. You got a tattoo of the guy who played the chimney sweep in *Run Ronnie Run*?

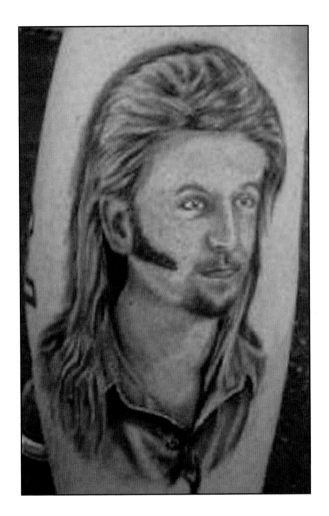

Whoa! This hair is WAAAYYYYY nicer on the dude's leg than it was in the movie. Oh, and funnier too.

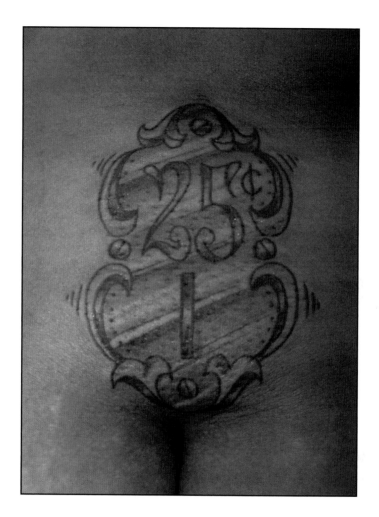

Boobies or tushy? Welp, for 25 cents I guess we don't care.

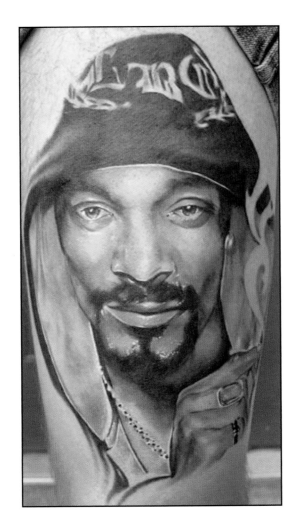

Just looking at a tattoo of this dude
gives me the munchies.

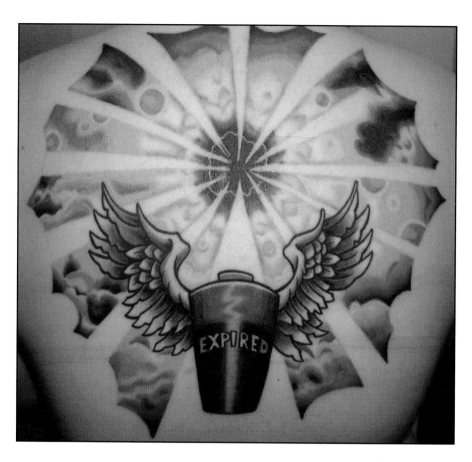

A backpiece dedicated to a dead battery? KILLER TAT, DUDE!

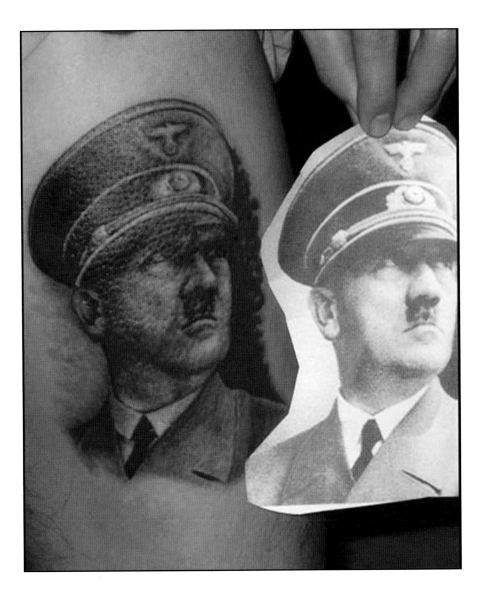

Aaaahhhh. . . . Those were the days.

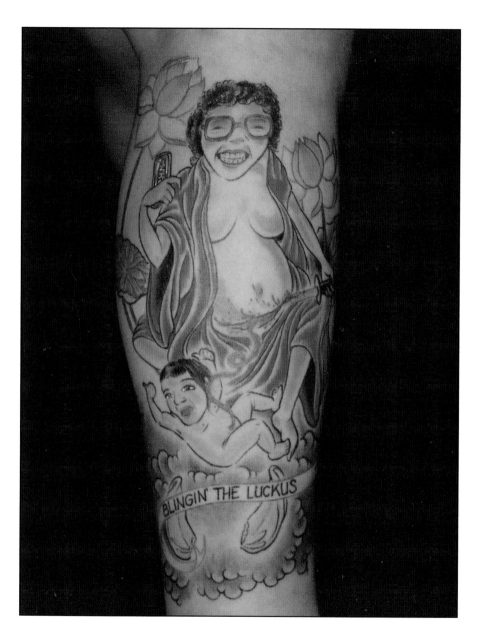

"BLINGIN' THE LUCKUS!!!??" This chick is bringing the ruckus harder than the Wu. It's a portrait of her mom in a monk's robe, on a cellphone giving herself a cesarean on a bed of lotus flowers. I know I'm a chick, but do you wanna get mawwied?

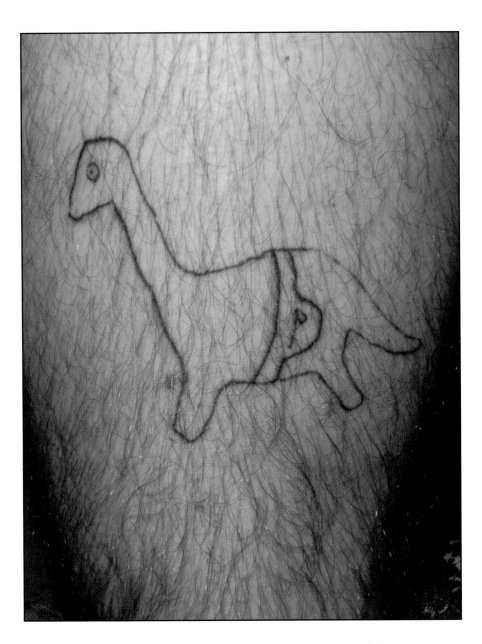

Dinosaur with a fanny pack?! Apparently, accessorizing to look like everyone on The Cobrasnake dates back to prehistoric times.

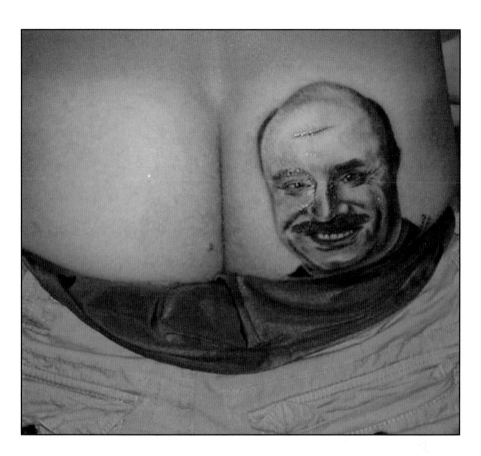

Finally, someone put Dr. Phil in his place.

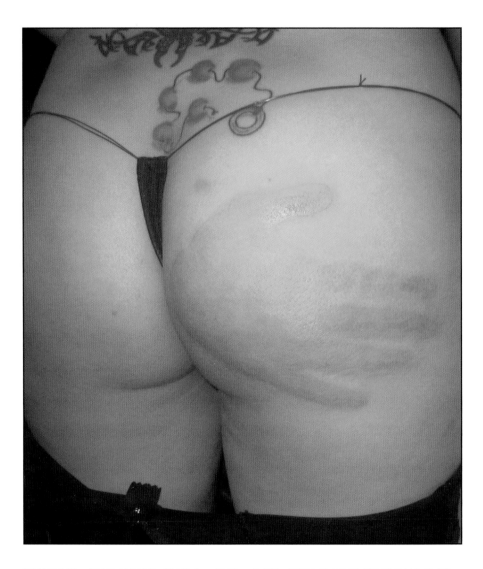

THIS TRIFECTA IS AN INSTRUCTION MANUAL FOR FRAT DUDES:

1) Tribal Tramp Stamp
2) Anal Beads
3) Donkey Slap

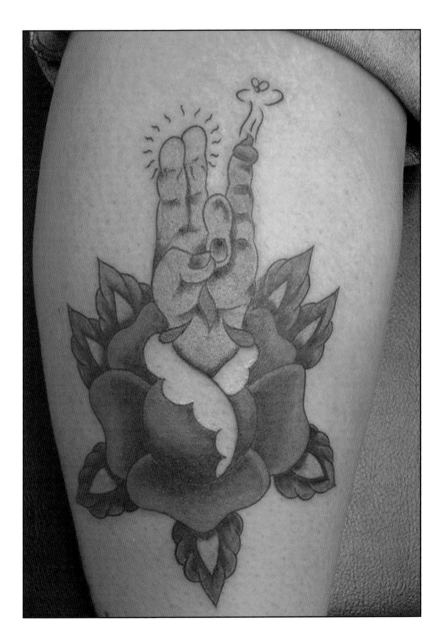

You know our pal with the ass-slap tattoo?
You guys should go have a quiet drink somewhere.

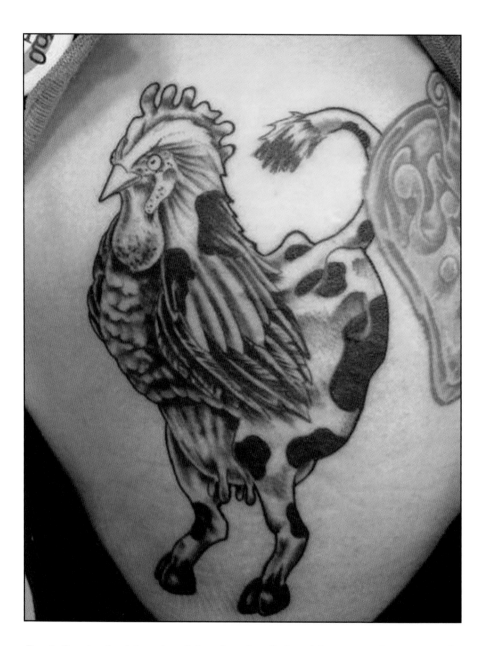

Beef-Cock. And her boyfriend got a fish with a taco for a mouth, shitting a bearded clam.

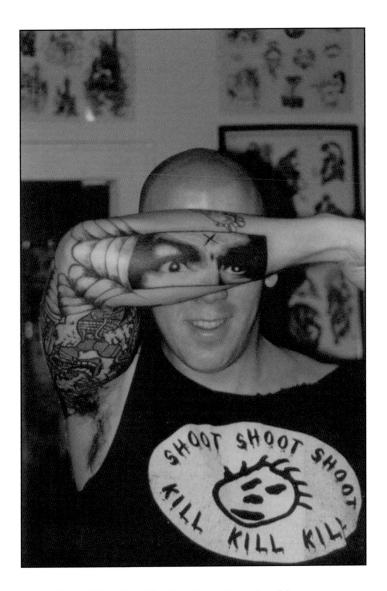

Goodbye, flipping the bird. Hello, flashing
Manson eyes.

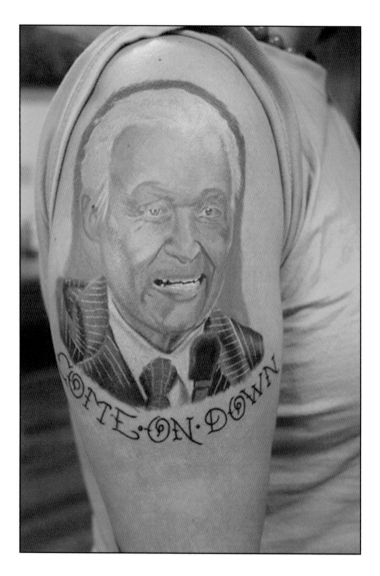

I bid $1, Bob.

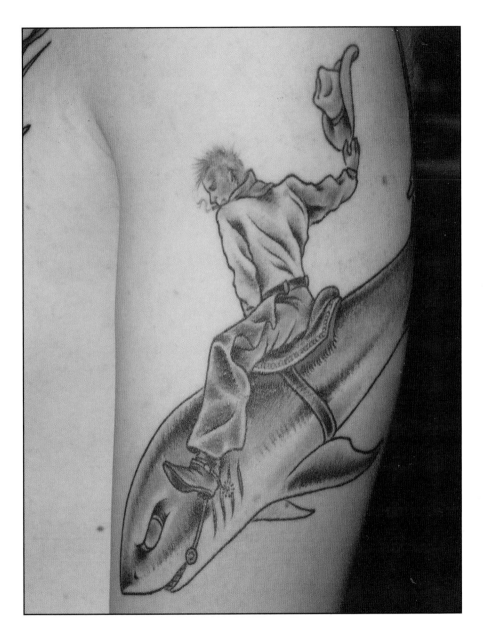

Marlboro Man
+ Shark
= Tattoo equivalent of a
 Red Corvette

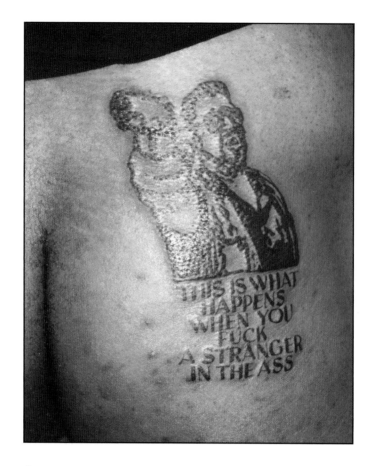

Can someone tell me the purpose of getting a tattoo of John Goodman in *The Big Lebowski* on your ass?

TAKE YOUR PICK:

1) Anti-rape statement
2) Prison challenge

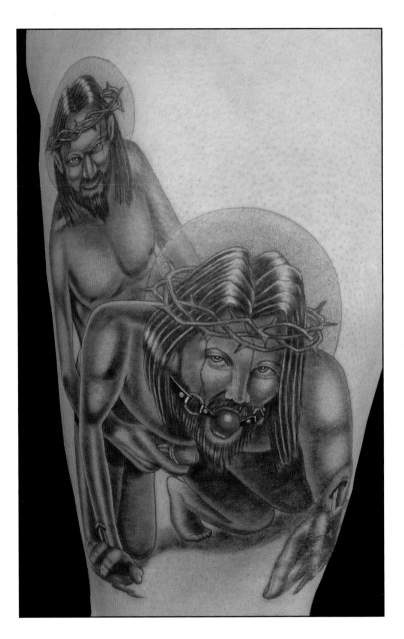

Jesus fucking Christ?
Jesus fucking *Christ*!

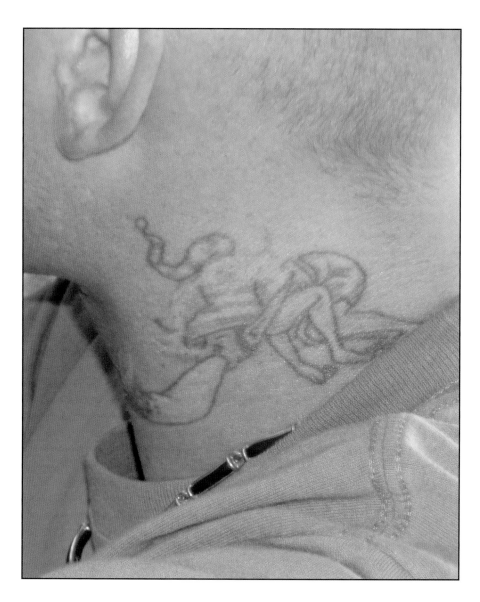

What's worse than rave tattoos? Look at that stupid Pixie smoking a giant spliff. I'm gonna gag. Go get your Dr. Seuss hat and your giant funny cigarettes and eat some GORP* at a full moon party in Thailand and stop making our eyes bleed.

*GORP: Granola, Oatmeal, Raisins, and Peanuts

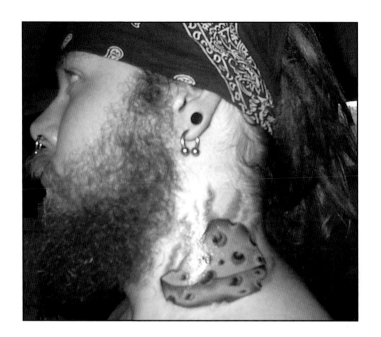

This. This is worse than a rave tattoo.

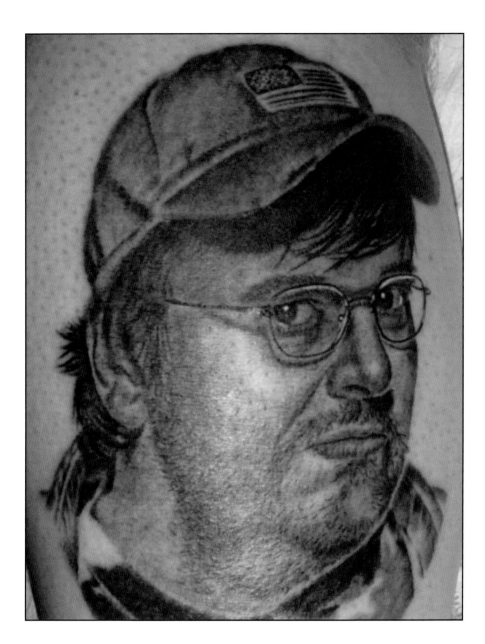

What's more annoying than an extra 340 lbs on your leg?

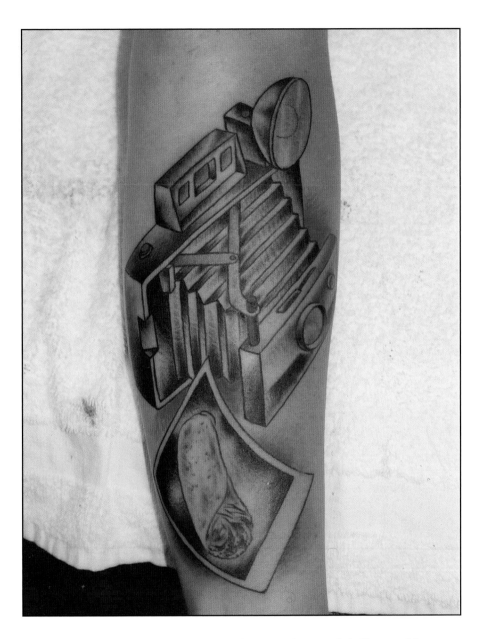

A burrito? That's more random than a photo of Julianne Moore farting on Rick James.

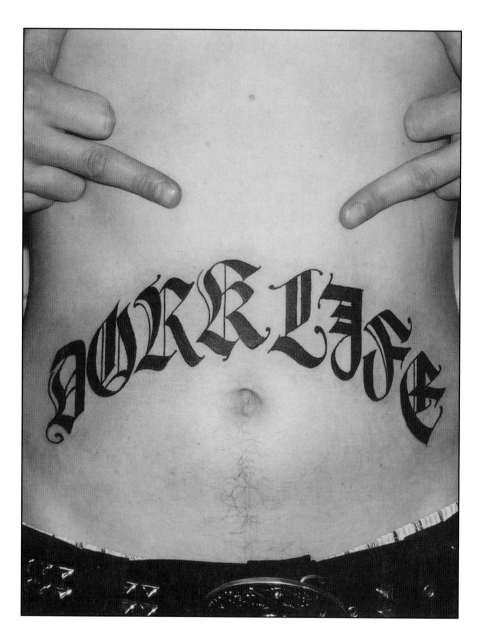

"Queen to Rook 3, bitch."

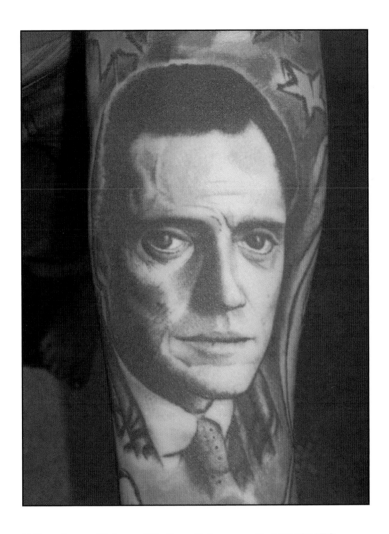

Who doesn't love Walken? Anyone? ANYONE?
The guy drinks *Champag-nya* and dances like a
jazzed-up mime, c'mon.

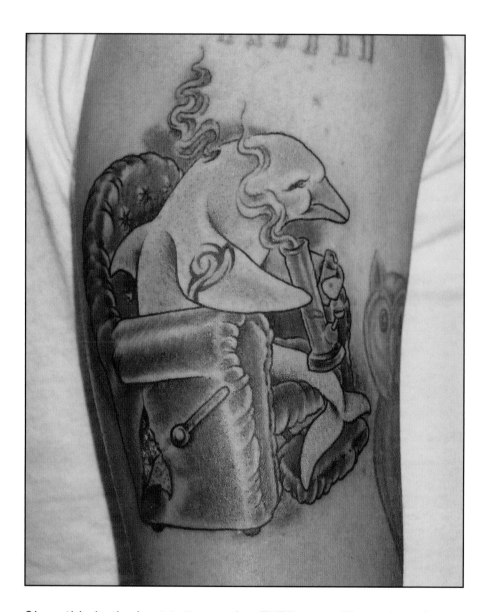

Okay, this is the best tattoo we've EVER seen. The artist told us this was the result of a lost bet (awesome). I can't decide who I want to give an awesome beej to more: the dude who thought of it or the dude who actually got it.

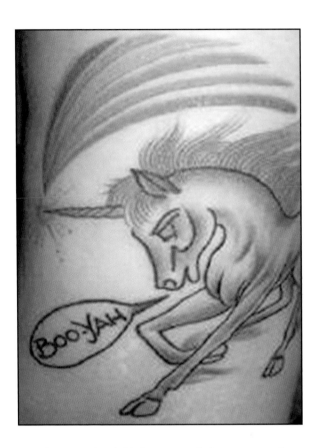

All the magical Unicorns of Greenwood
Forest speak Ebonics.

I didn't know the Crocodile Hunter was in *CHIPS*.

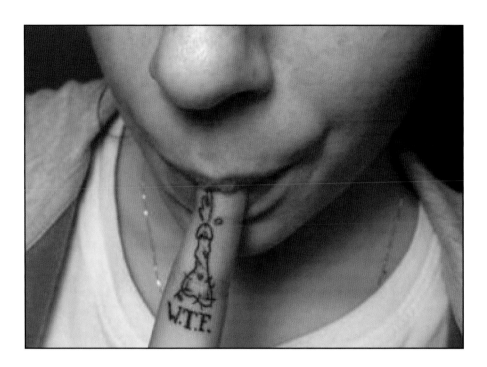

Ummm . . . you tell us.

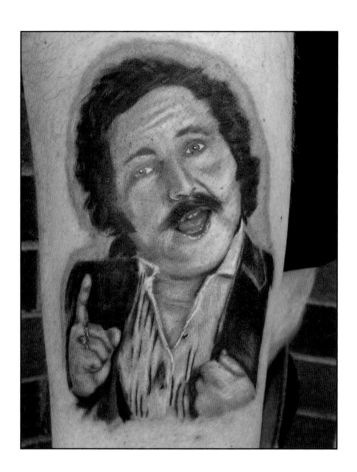

Have you guys heard the new Har Mar
Superstar album?

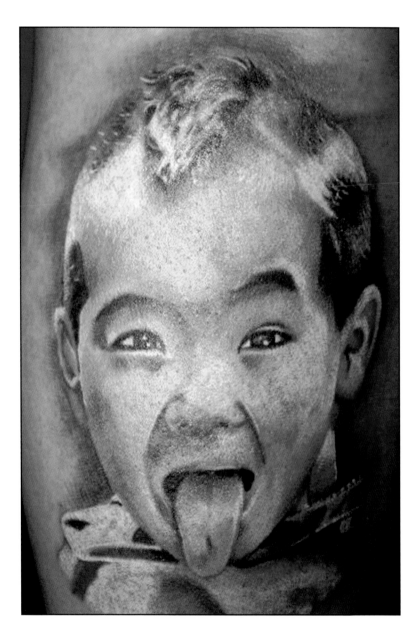

WASSSUUUPPP!!!

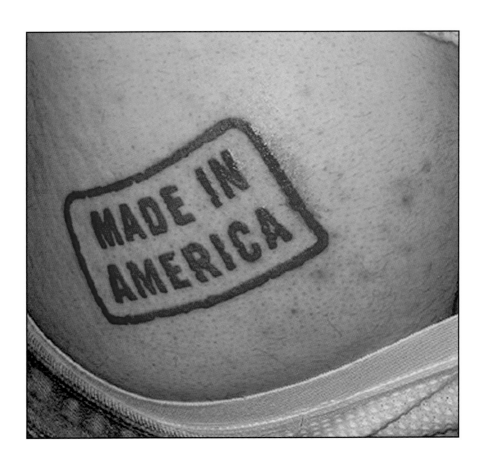

So you're going to rep us with your prime USDA ass-ne? Sorry, I love the tattoo. Can't get past the canvas.

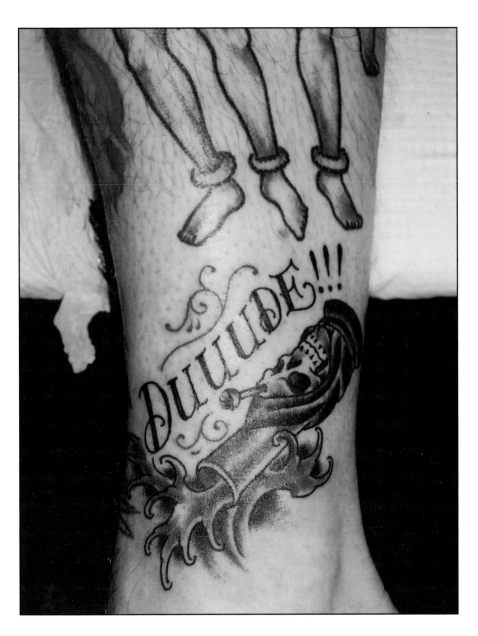

Duuude \ doood \ *n*: The universal sound that Homo sapiens make when someone spills the bongwater.

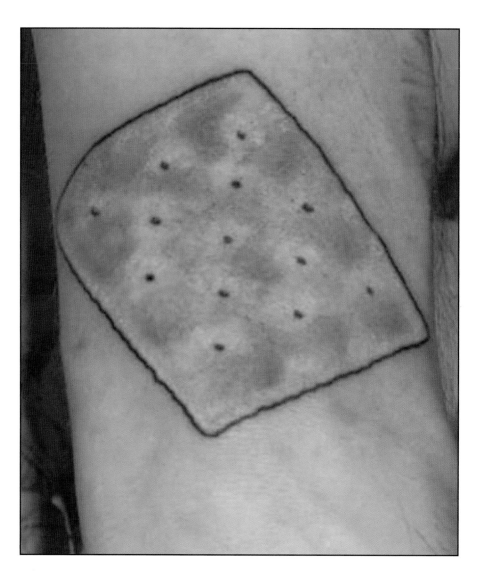

White Pride is so in right now.

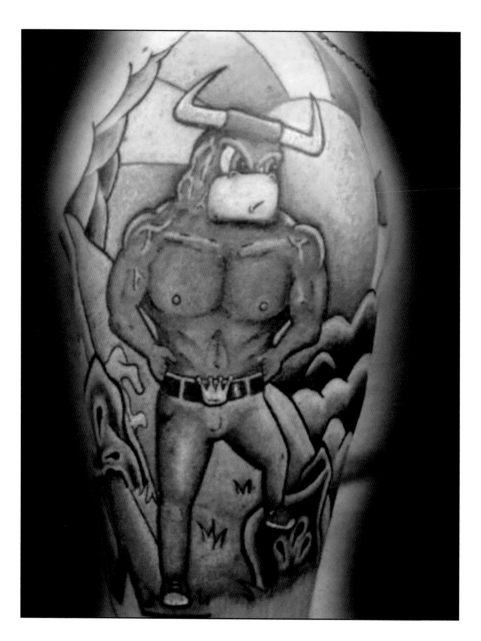

What's up with Sexual Chocolate having teeny-weeny little wootzies for feet?

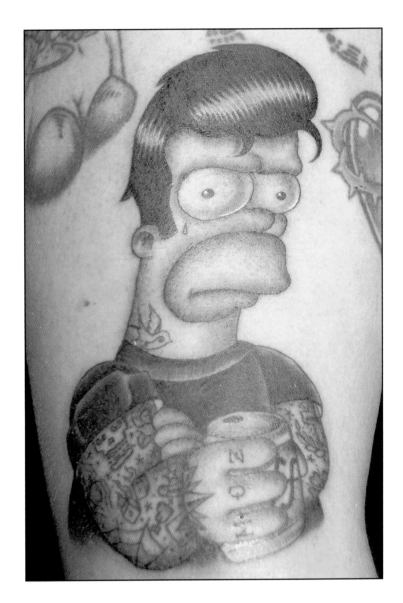

Okay okay okay wait HOOOOLD on. You have Homer
tattooed like a Mexican Gothabilly/L.A. gangster
with MOZ on his fist? Excuse me, but I'm feeling all
tingly in my special area. Call me!

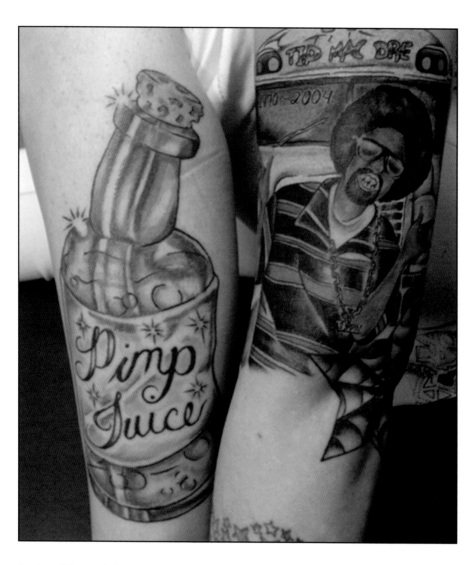

3-day Pimp Juice bender = tattoo of obscure dead Vallejo rapper

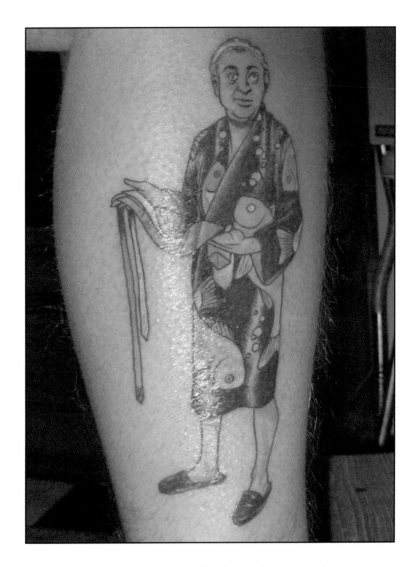

Obviously everyone loves Rodney. In fact, when we were writing this book we came across about 100 Dangerfield tattoos. This was our fave. Triple Lindy!

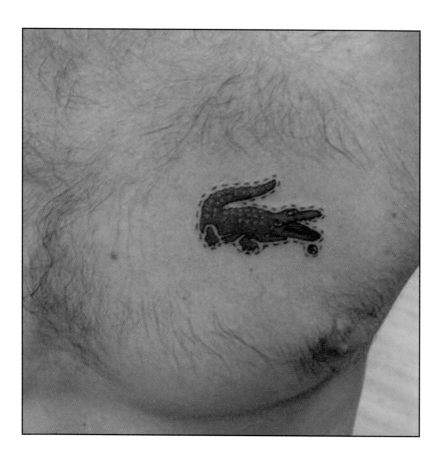

Now preppies are getting tats? It's over, people! Nothing to see here, folks. Go home to your families.

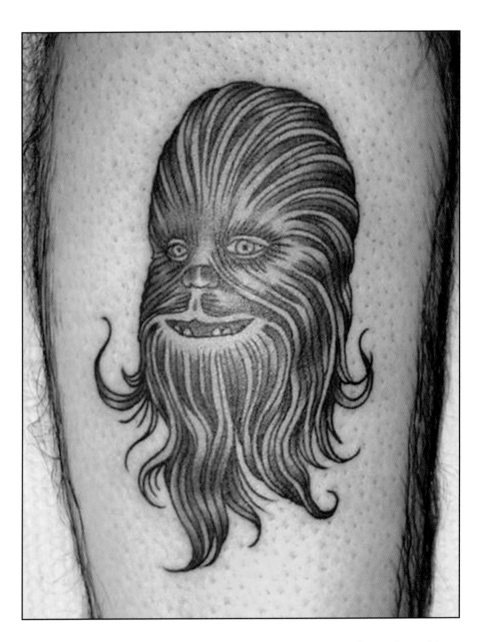

There are about three million Chewy tattoos out there, but this is the funniest rendition I've ever seen. I could look at this every day for the rest of my life and still get a chuckle. Dude, look at it. It's. So. Good.

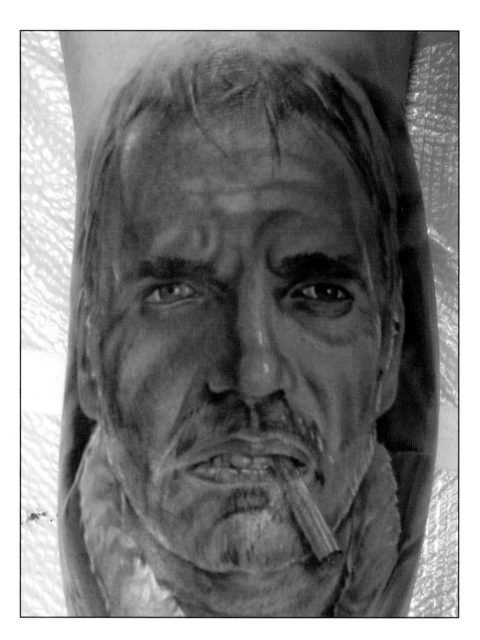

Holy what the shit on God's green Earth?

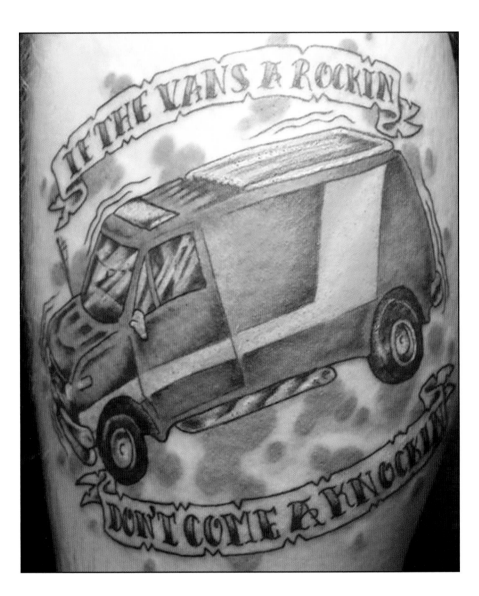

Get in my Rastafarian Rape Van, ladies! There's Alizé and a bean bag inside. Sound tantalizing?

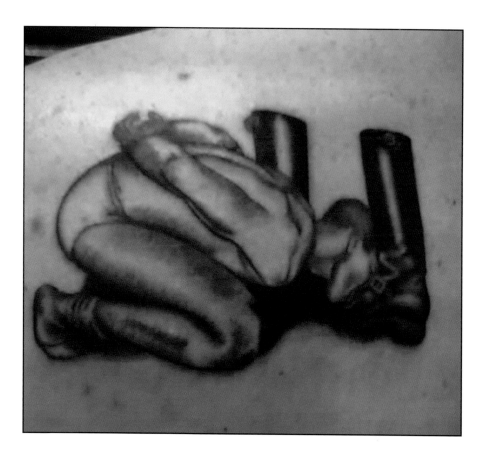

This guy has such a bootlicking fetish he doesn't even need anyone to be wearing them. And the socks are a nice touch too. Really brings us there.

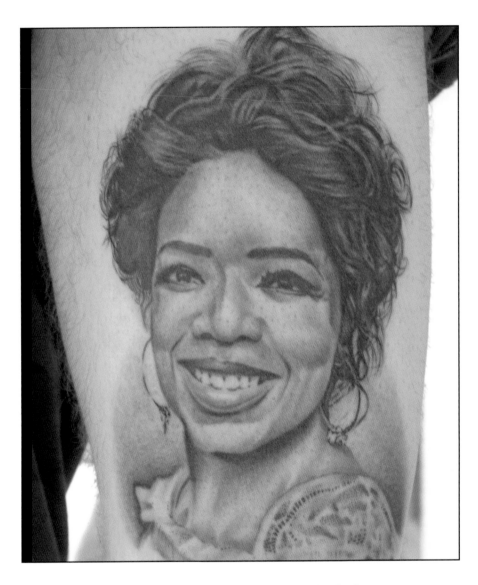

WHO OWNS THIS TATTOO?

1) Tyra Banks
2) RuPaul
3) One of Oprah's key demographics: a Bon-Bon-popping depressed divorcee with nothing left after her husband left her with two brats for a younger, hornier version of herself.

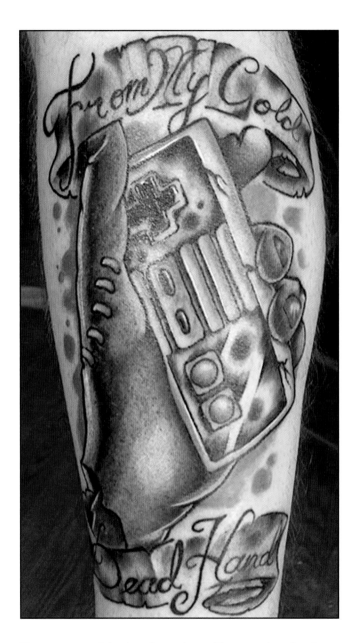

From my cold, dead vagina. My ovaries just peed themselves out and flushed themselves down the toilet.

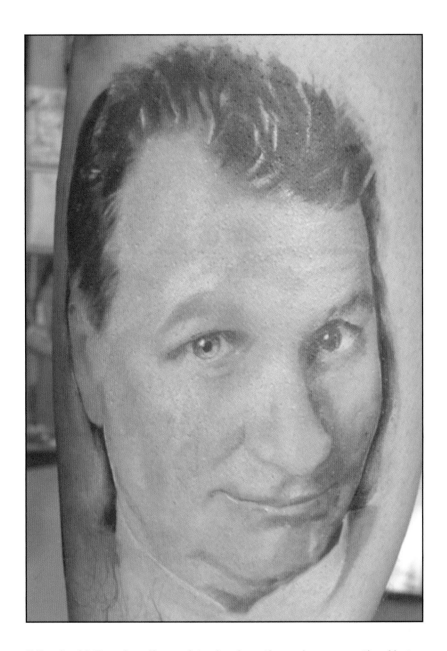

Why is Al Bundy allowed to be in other shows as the Not Al Bundy guy? Why mess with perfection?

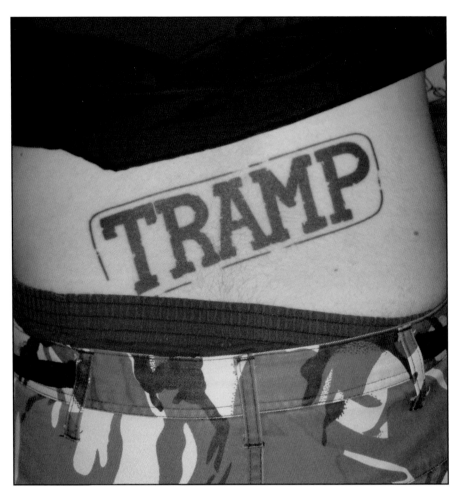

I know I'm a girl and yer a guy 'n' all, but this tattoo still makes me wanna feed you Jager shots 'til you pass out, tell you yer purdy, donkey punch you, and never call you again.

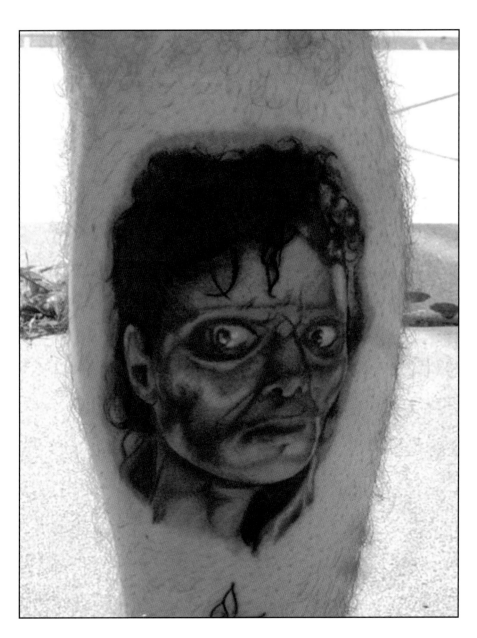

LOVED you in the YouTube Cebu Prison video.

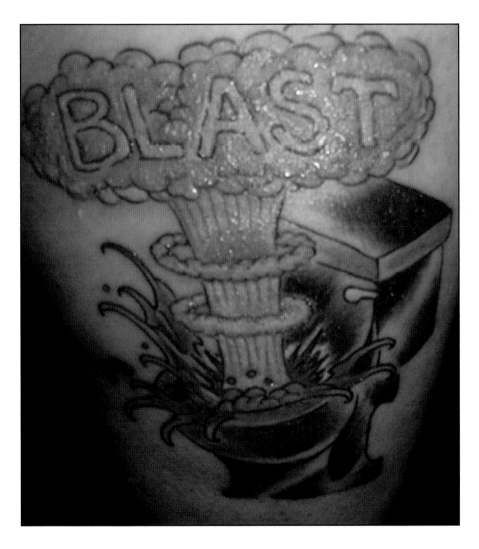

This is a testament to how irresistible potty humor is. For us, this is a dinner party MUST.

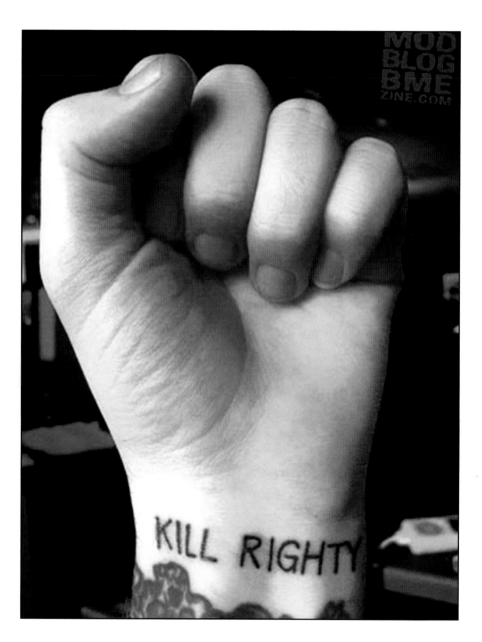

I don't have a joke here, I just wanted to get this in the book.
It's awesome.

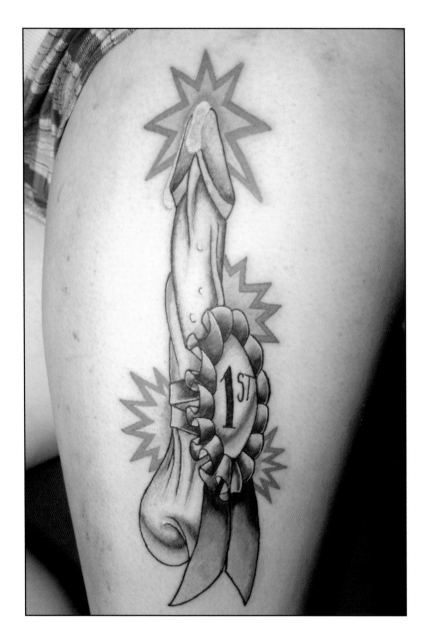

Whoa . . . Donny got First Prize for droopiest
green balls?

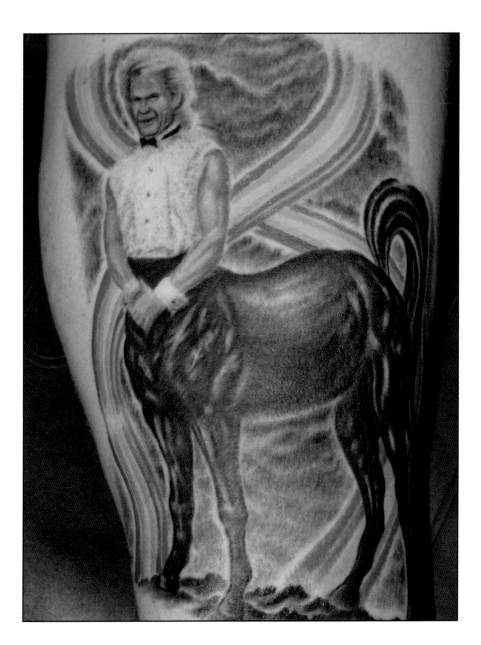

"THE SWAYZAUR"

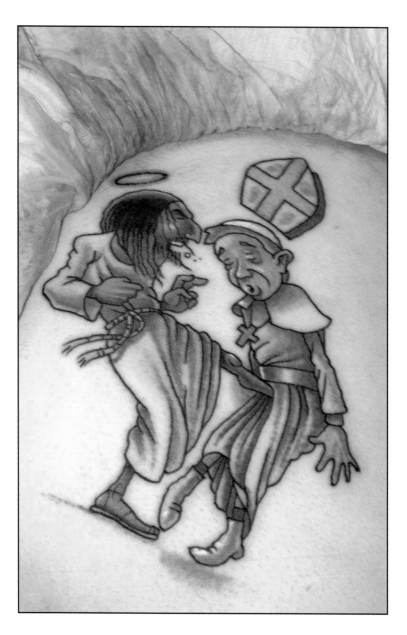

OOF! Right in the holy ballsack.

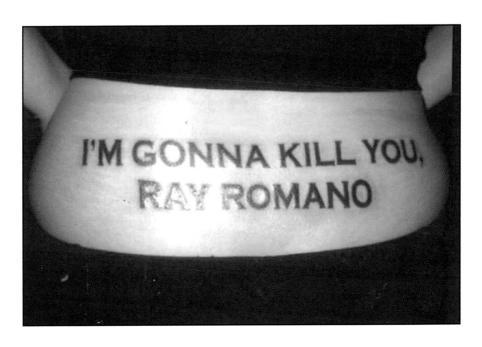

Who are you and why aren't we friends?

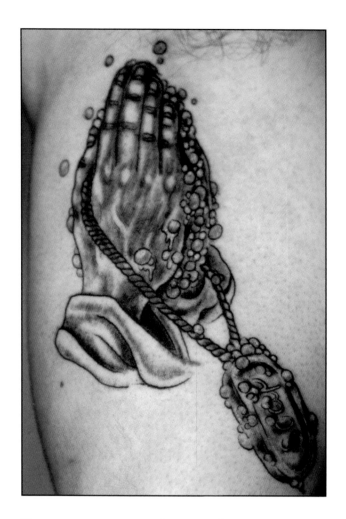

Come here, my son. Let me cleanse you . . . in the most homosexualiest, rapey, cringe-inducing way.

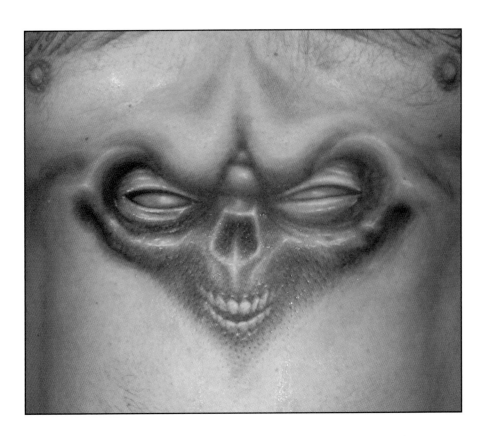

You know how when chicks think you made out with their boyfriend and they look at you with HBA (Hot Burning Anger)? This is how it looks.

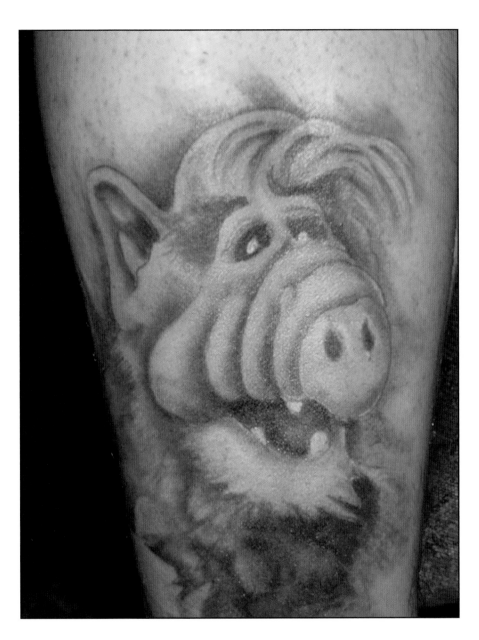

Guy: "Gimme the most insane, ridiculous tattoo that will still get me laid. Anything you want, go nuts."

Tattoo artist: "NO PROBLEM!"

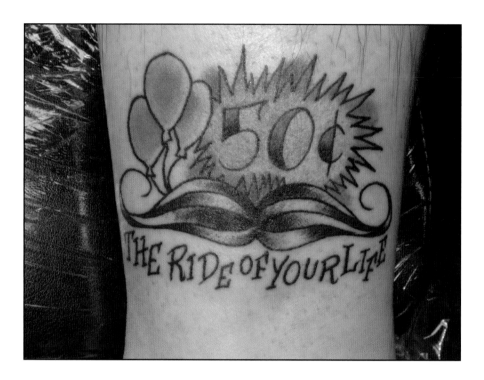

So we have to pay 50 cents to hump your ankle? I guess that's kind of hot if you're a poodle.

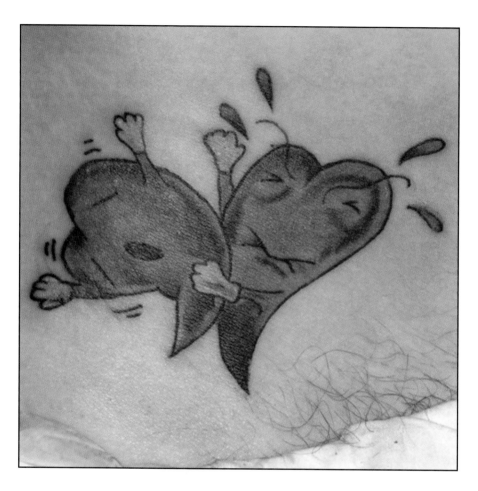

The romance, the love, the affection . . . wait . . . The wincing, the pain, the screams.

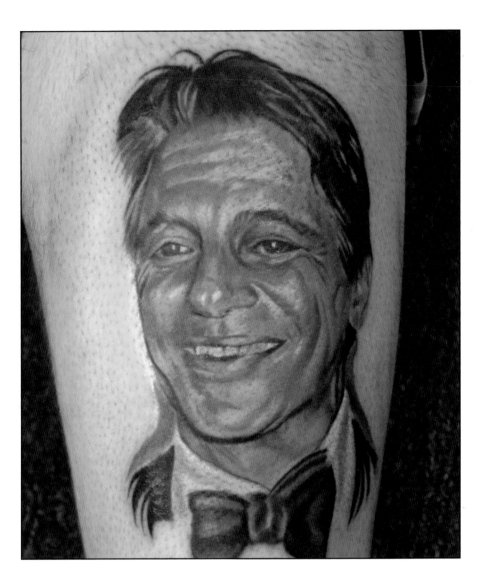

From the *Time Burglar Manual*, p. 123:

Chapter 7: *Parties and Events*

Getting a tattoo of Tony Danza is the most effective way to burglarize people's time at a party. Since it takes an average of five minutes to explain the "why" of your tattoo, we estimate you can steal at least an hour from any given social function.

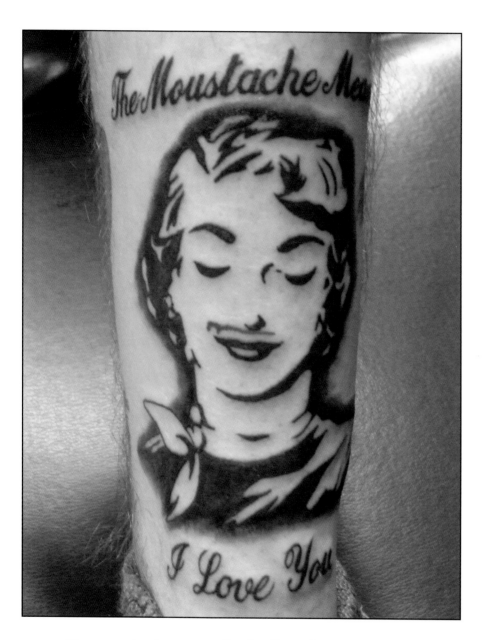

The moustache means I'm barfing all over your leg.

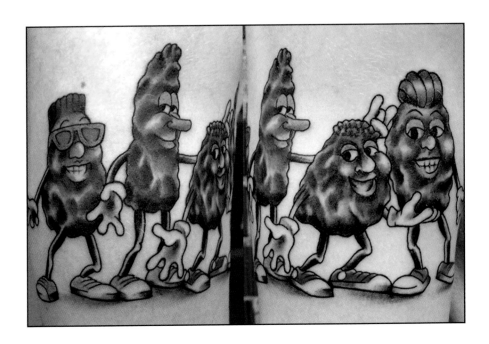

I know somehow this is racist: I'm not sure how exactly, I just feel it in my bones. Anyhoo . . . bowl of milk and some bran flakes. Let's do this.

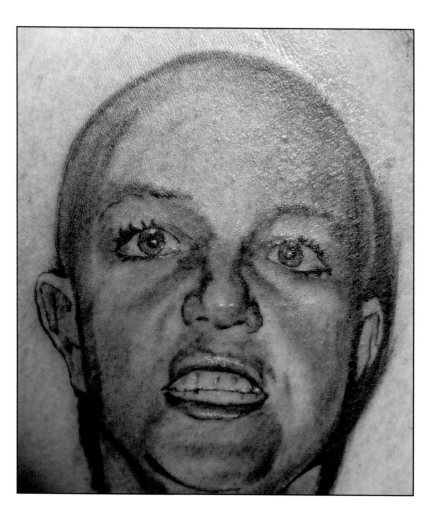

Hmmm . . . maybe *some* regrets.

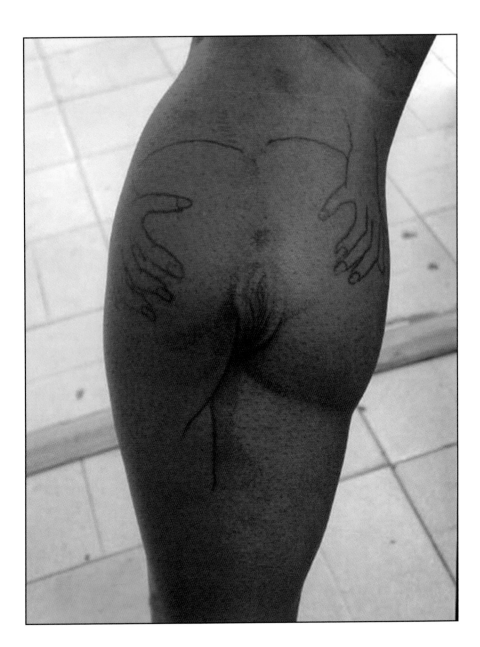

I know it's sexy to have a gaping asshole and steaming vagina on the back of your leg, but if for ANY REASON you end up in prison, your leg is getting raped.

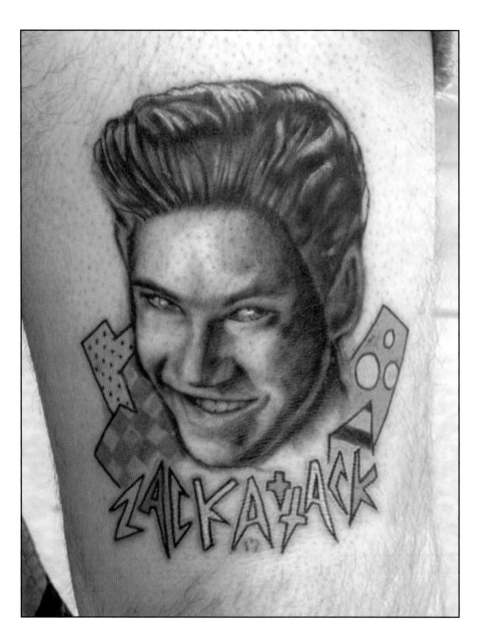

While Zack is on a meth holiday, the other leg has Slater sitting on a mushroom smoking a hookah.

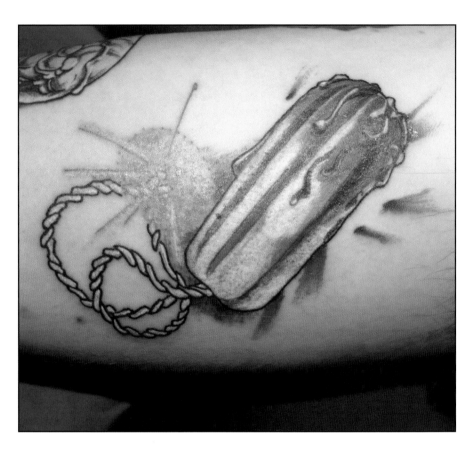

Blueprint for how to kill your whiny girlfriend: light her tampers aflame.

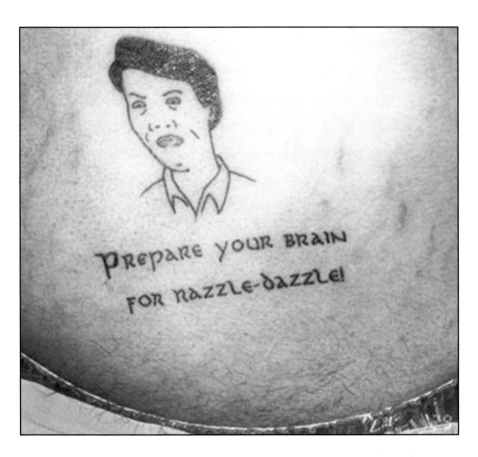

Add this sentence to your "zingers" file and pull it out on all your first dates.

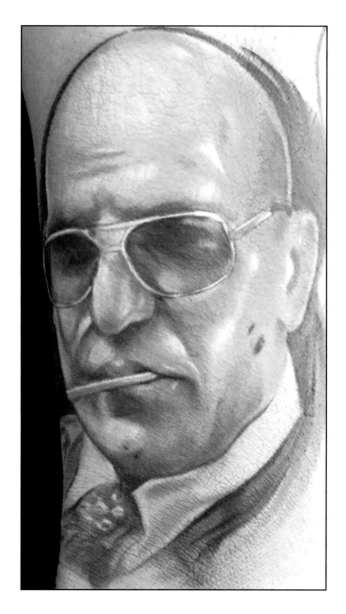

Kojak was the first bald badass cop on TV
and the reason LL Cool J rocked lollipops.
I'm telling you this because if you're reading
this book you're probably sixteen and don't
even know what you're looking at.

DJ Paul Oakenfold, Ibiza, 1997 . . . Esteban was
rolling his face off.

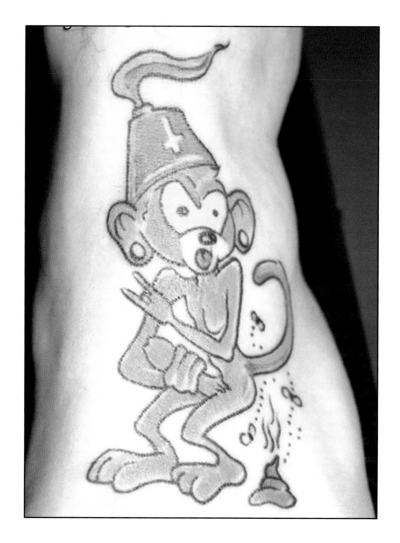

MY NEW TATTOO WISHLIST:

√ Creepy masturbating rape monkey
√ Satanic shriner's hat
√ Steaming pile of monkey shit
√ 20g pierced earlobes (for detail)
√ Metal hands
√ Gross-out factor of 10

Yep, all there.

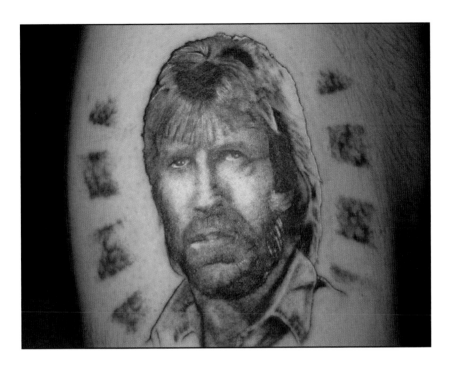

Don't make eye contact with this. Looking at Chuck Norris in the eyes is like watching *The Ring*. You won't know it, but you'll be dead within a week.

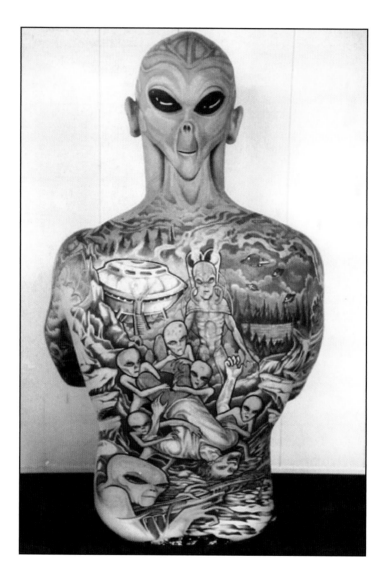

Dwight, your father told you not to go in the shed!

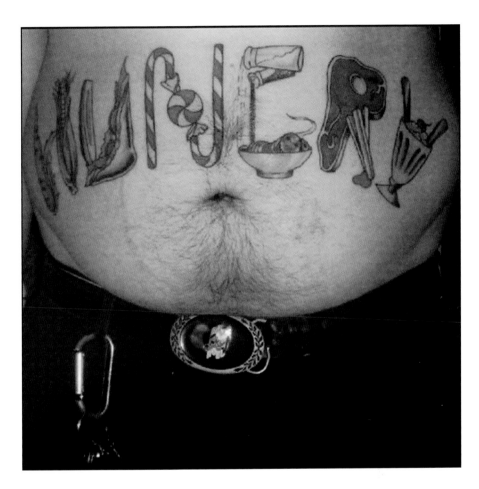

Clearly.

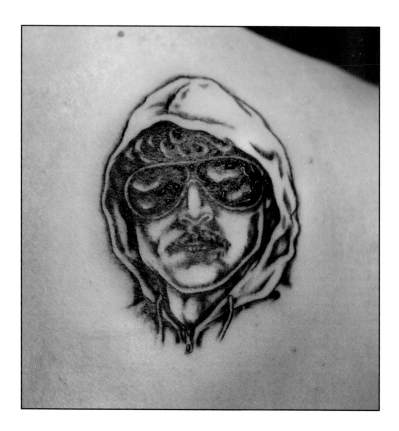

Unabomber or soldier in the Generic-Hipster-
Uniform-Wearing-Douchebag Army of Williamsburg?

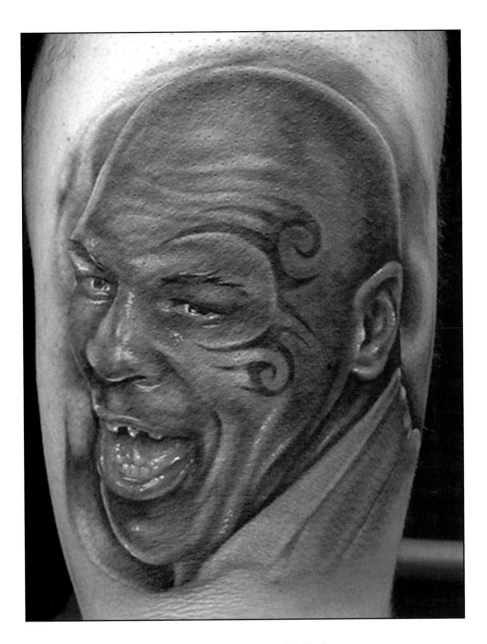

Best tribal tattoo EVER!

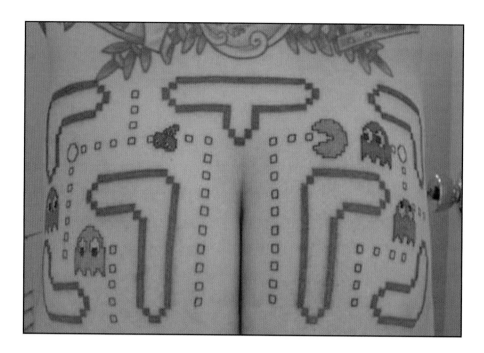

The tattoo is amazing and all that good stuff, but can we talk about how dreamy this guy's butt is for a tattoo artist? It's a flawlessly flat, square, solid drafting table. This is the Venus de Milo of ass tattoos. A phoenix, if you will.

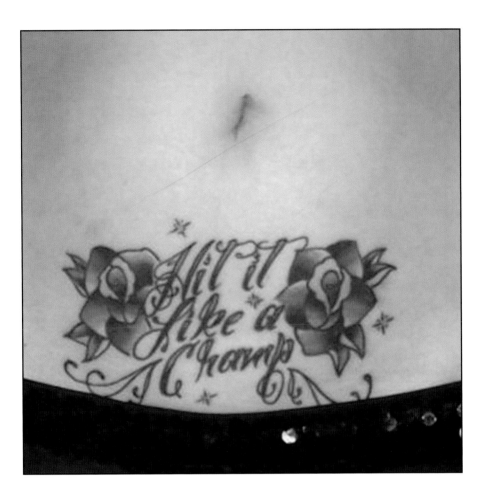

Translation: "Make love to me in the way I most desire to be loved by a man. Please caress me daily and give me your utter devotion and respect."

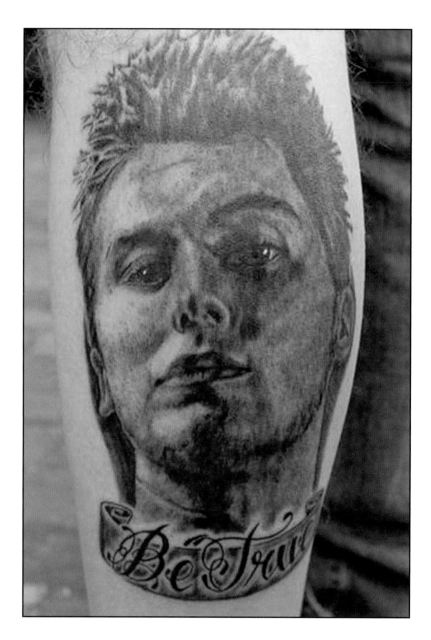

Um, 'scuse me, sir? I don't wanna be a pill, but can you tell us why and how Lance Bass became your hero? No, really. I can't sleep at night until I find out.

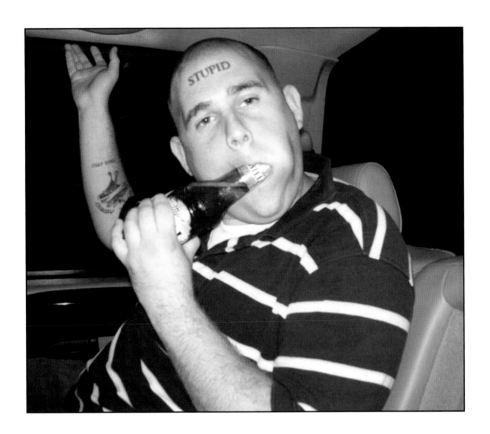

Thanks for the heads-up, guy. By the way, in case you want to make fun of him he has a preemptive "FUCK OFF" on the back of his head. I'm not kidding.

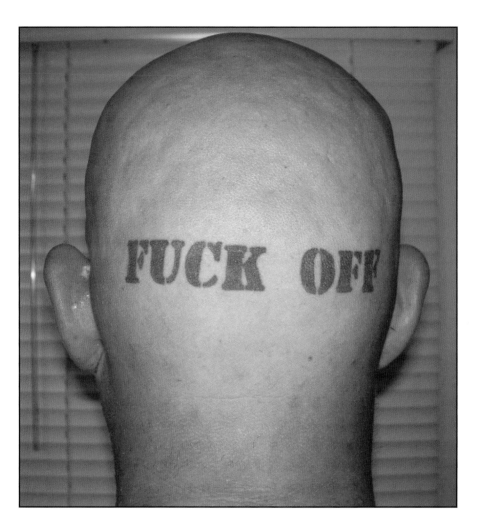

See? We told you he would get the last word.

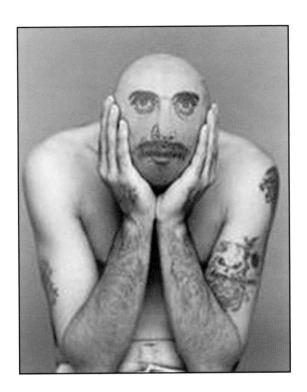

Bros: If you get a tattoo of your face on your bald head, no girl will ever EVER be able to have the last word again.

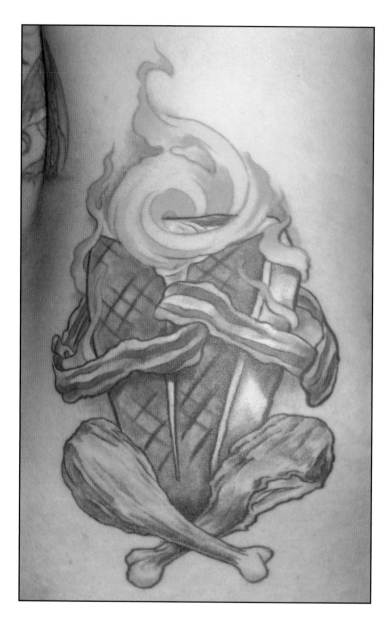

If you move to Portland and have to live with
a bunch of Straight Edge Vegan Nazi bike
messengers, you'd be inclined to get this tattoo.

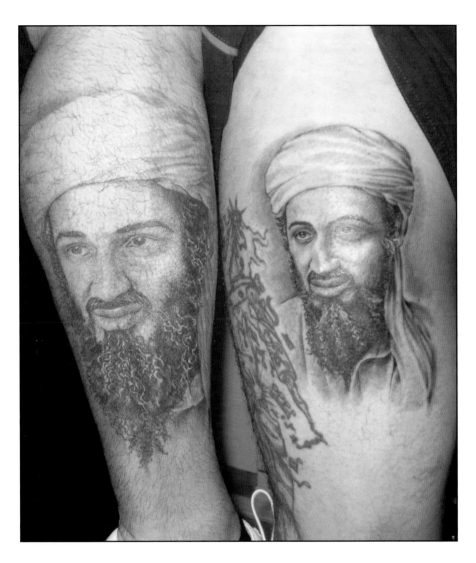

If some patriotic mouth-breathing rape-squad dudes-who-troll-bars-for-sluts-and-fights find you and kill you, don't come crying to me.

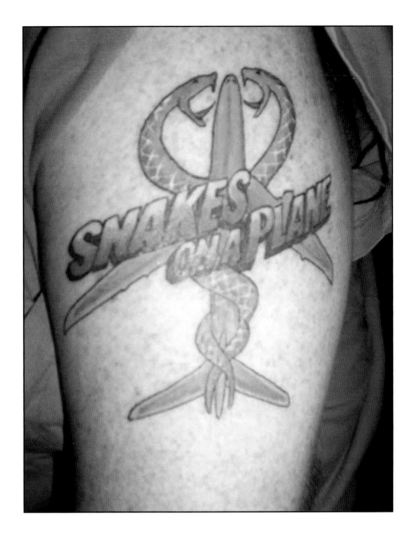

Snakes on a Plane on a douchebag.

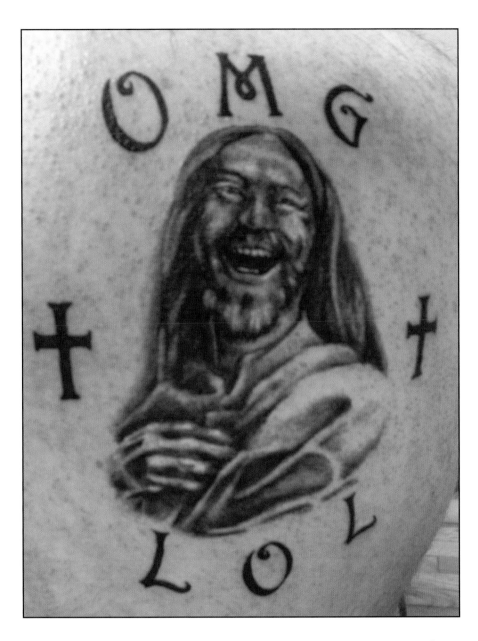

WTF? OMFG! ROTFL! LMAO! 2G2BT! BTW . . . JC = BFD. JC
BMFIC! AMF!

If you are the title holder in the *Guinness Book of World Records* for "Hairiest Mole," why not make friends with it? Embrace it. Give it some personality and let it become its own entity, like a conjoined twin.

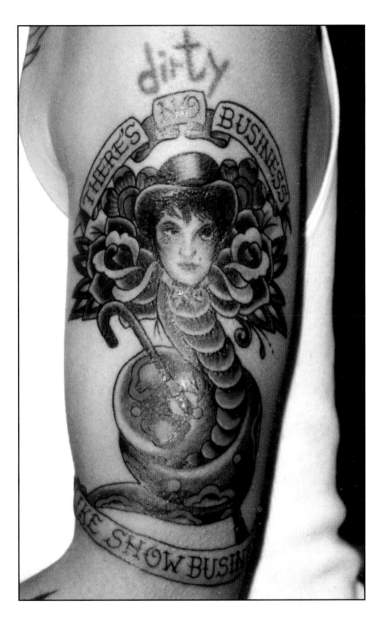

Liza Minelli in a Fosse musical as a snake? All
that's missing is a pair of Jazz Hands.

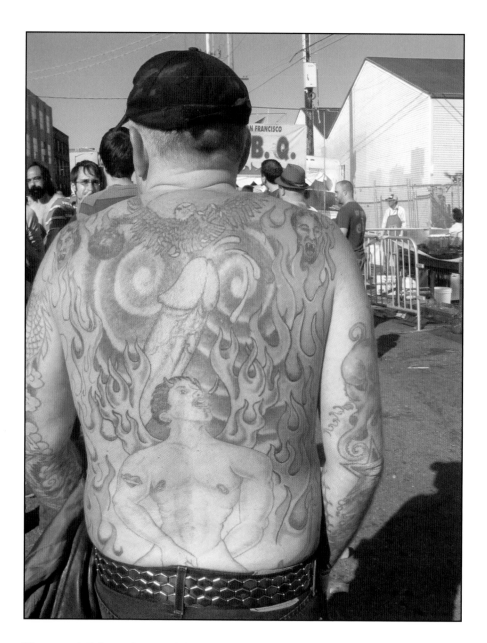

The cool thing about older leather queens is that they just don't give a shit what we think anymore. Must be such a relief.

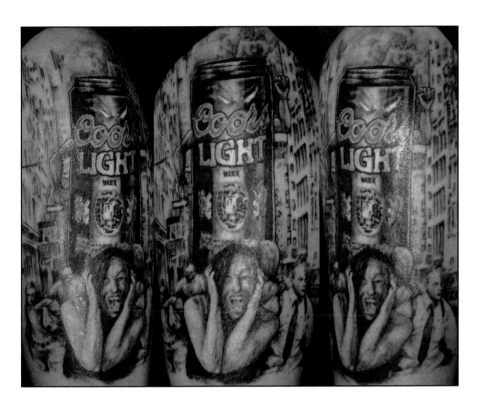

Remember that ad from the '90s when the Coors can was crushing Manhattan like Godzilla? It sucked . . . until someone made it into a tattoo and turned it into comedy gold.

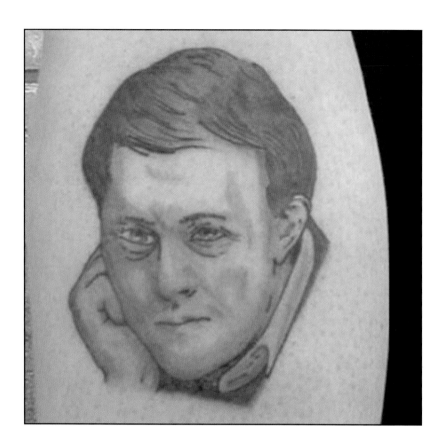

Corky's doing Rolex ads as "The Thinker" now?
What's next, Marlee Matlin in an iPod commercial?

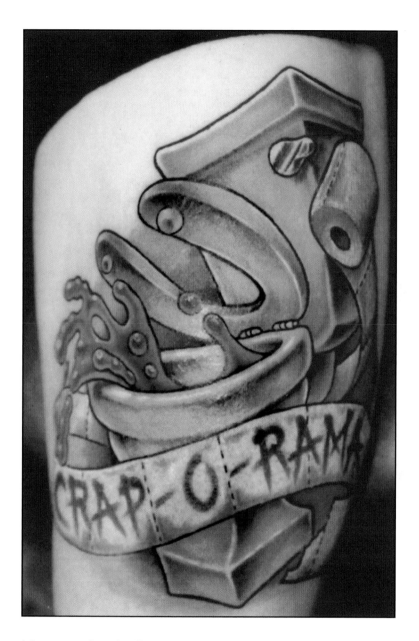

I know we're dealing with a potty here, but isn't that kind of the most scintillating, enticing toilet we've ever seen? The water is a sparkling, brilliant blue. I'd drink it, just sayin'.

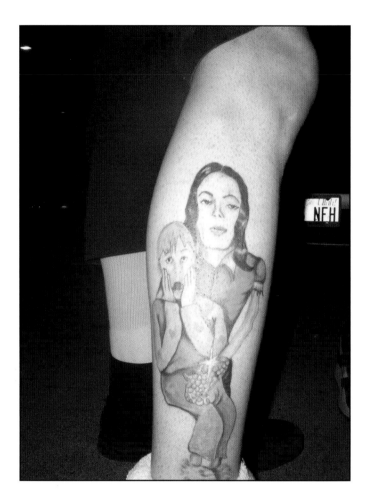

I'm pretty sure that's MJ giving a HJ to MC.
YIKES!

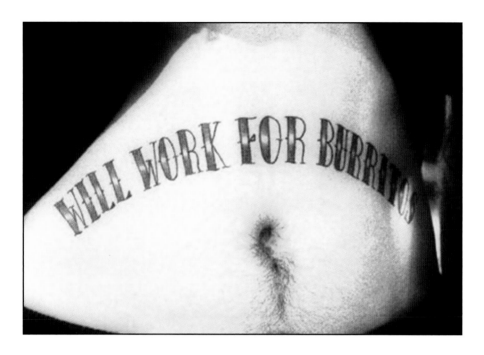

I am with him on this. Have you ever had one of those delicious food logs from a taco truck in Echo Park? It's like they have a wizard in the back making your dinner.

Meatwad on your dog, dude? Really?

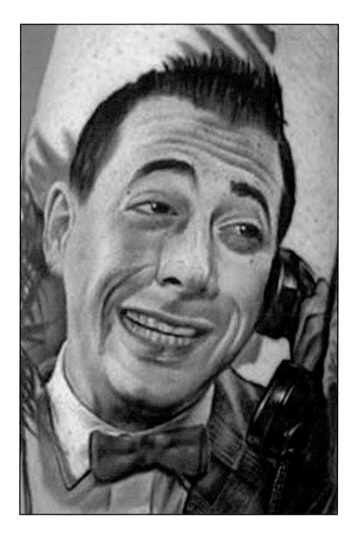

"Helloooo? Oh hi, Mr. Parole Officer. No . . . I didn't like *Edward Penishands*. The technical direction was off. You should pick up *Sperms of Endearment* . . . LOOOVED IT!"

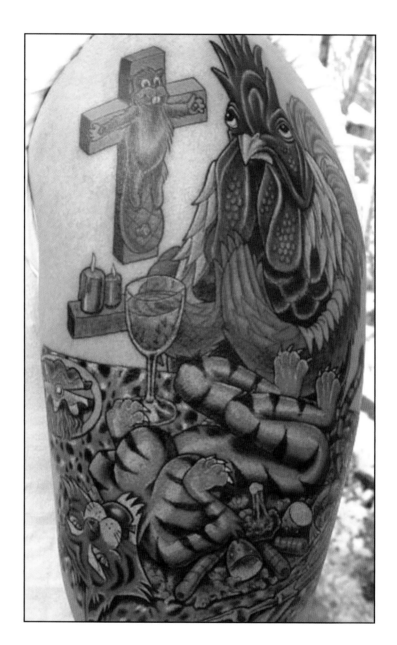

This is the *Where's Waldo* of sexual innuendos.

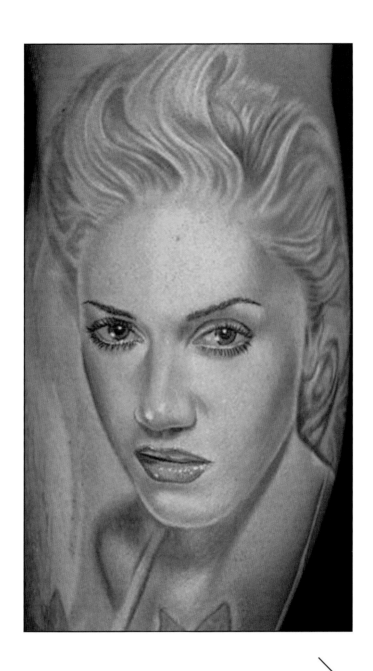

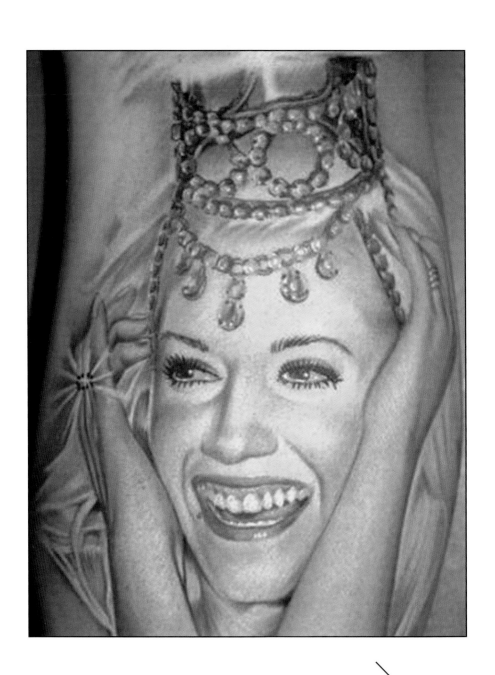

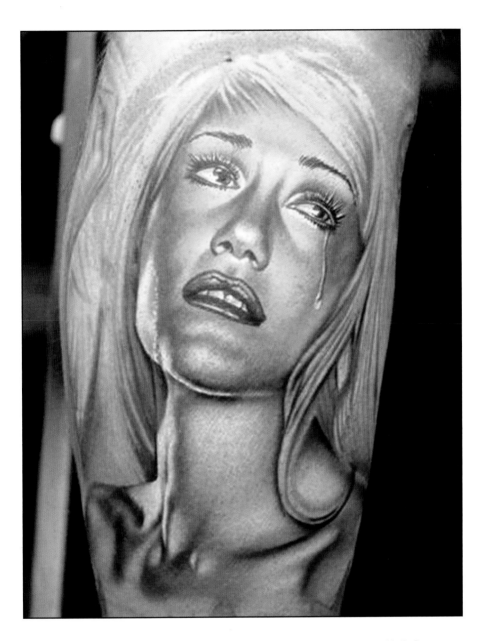

Three beautiful Gwen tattoos: not funny. Three beautiful Gwen tattoos on the same dude: 9.5 on the hilarity meter and a 7.0 on stalk-o-meter.

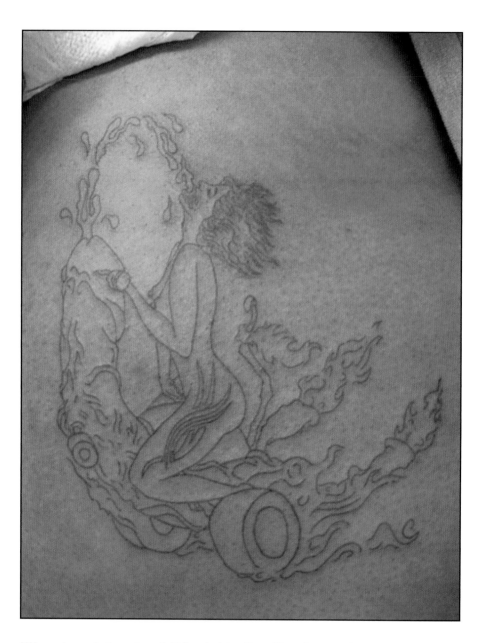

I'll make a joke about this right after I'm done with my bleach bath. Ew. Yilch. Blarf.

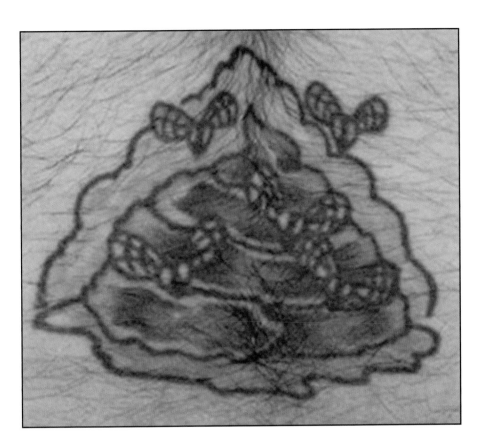

The *Mona Lisa* of shit-pile tattoos.

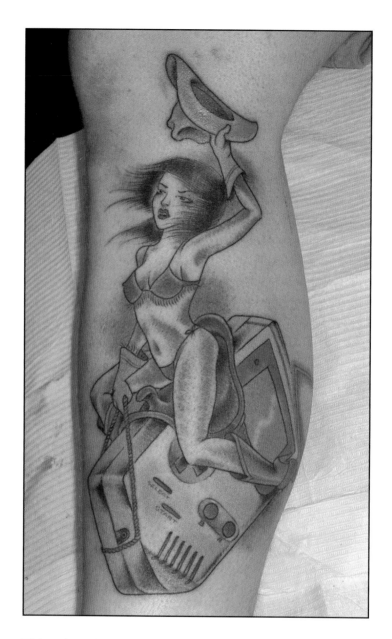

This piece is titled *Every Teenage Boy's Fantasy* (1994).

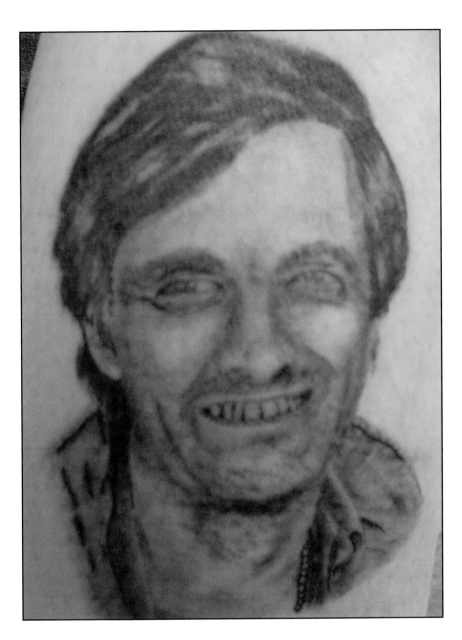

Alan Alda looks like he's saying "THEEEENKS!"

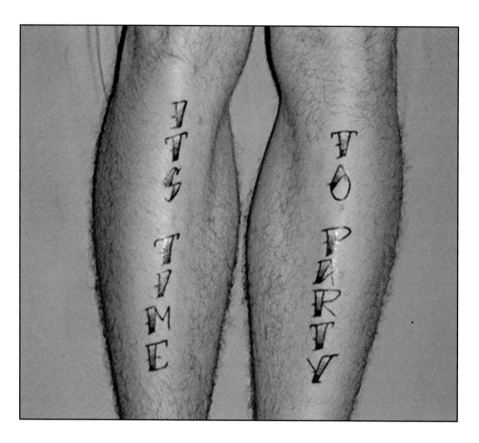

This guy doesn't need bongos and a bag of coke to bring the party. He just shows up in shorts with his PARTY LEGS and brings the PARTY VIBES. Even his grandchildren will be high-fiving him when he takes them fishing.

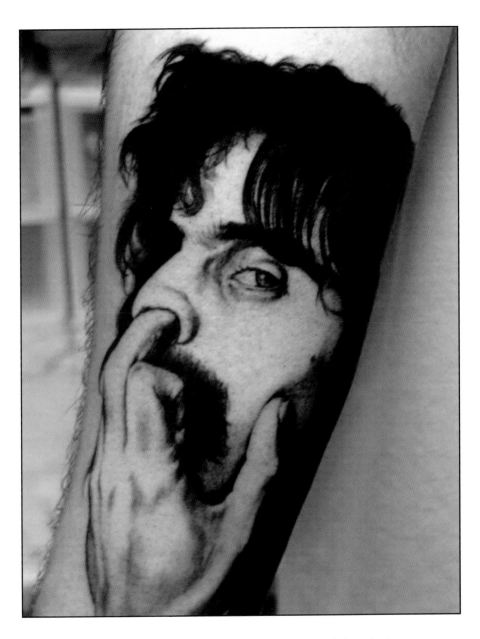

It's already a big "fuck you" when someone picks their nose while looking you in the eye, but when Frank Zappa does it, it's more of a "fffuuuuuucckkkk yyyooouuu!!!!!!!!"

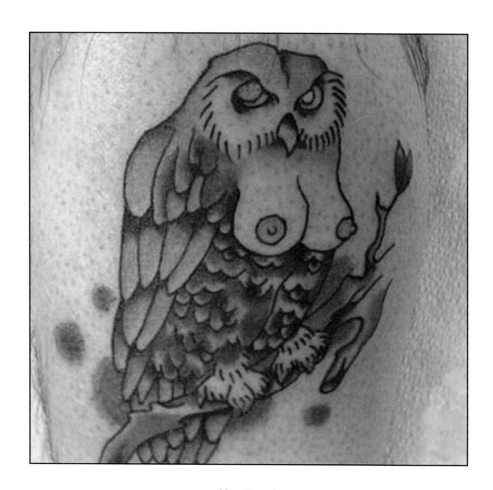

Hooters!

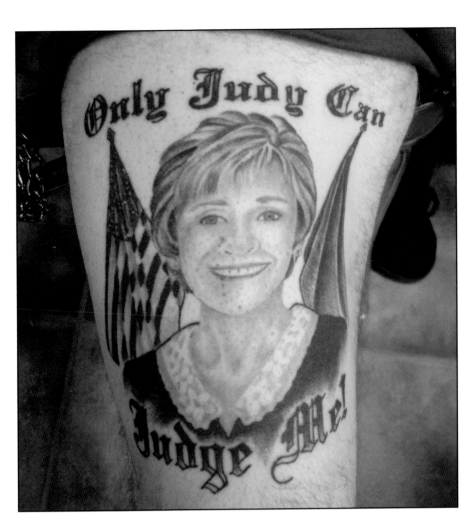

Nobody's judging you. Except everyone who ever sees this.

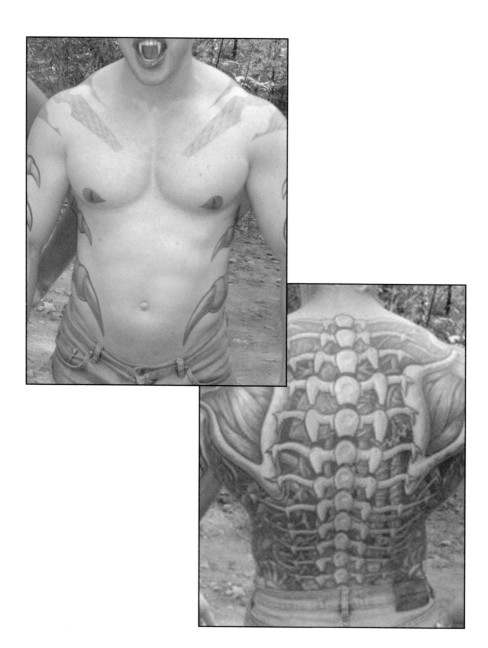

And now for a good old-fashioned eye raping. . .

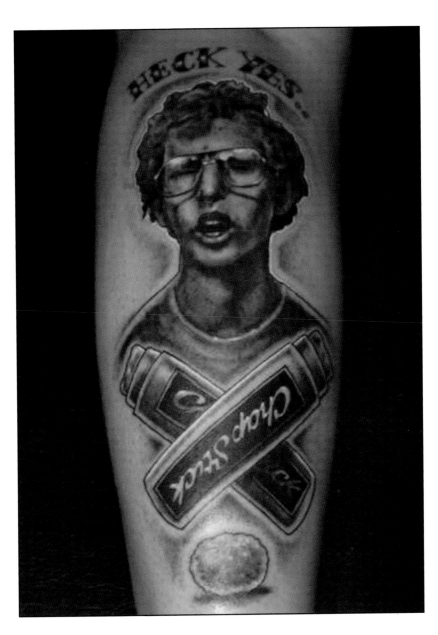

Go ahead, crucify me, but I hate Napoleon Dynamite and
Pedro is annoying. Please send all hate mail to the publisher.

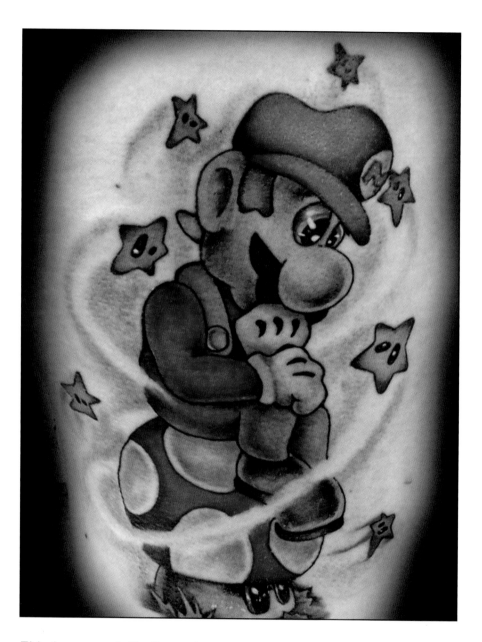

This is some sixth dimension post-Trekkie String Theory reality that we know nothing about.

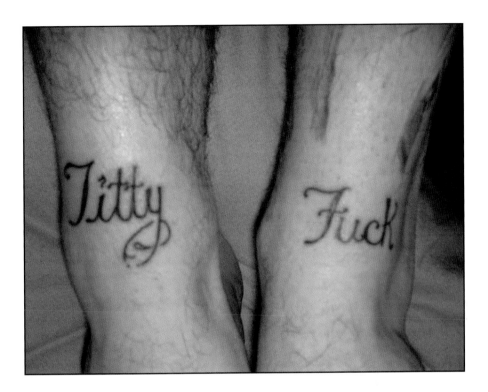

"Titty Fuck" on your ankles? No big deal. Just a polite suggestion for your wife in case she forgets your favorite thingy: Simply remove your socks and gently remind her with your instructional tattoo.

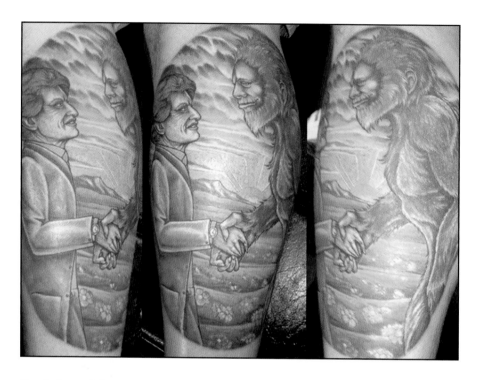

Povich and Bigfoot agreeing to be in this absolutely ridiculous tattoo.

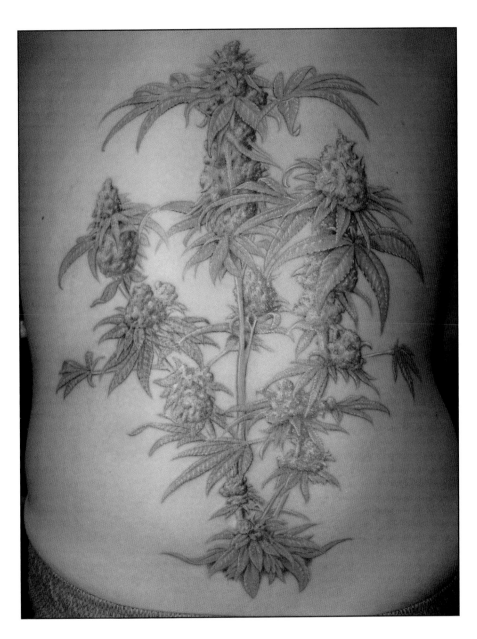

I bet your pubes are dreadlocked and you have at least one child named Ocean with a squatter chick you met at the 420 Hash Fest back in '97.

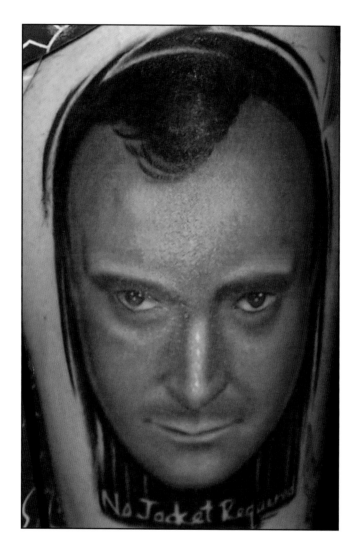

Jesus CHRIST what did you do to Phil Collins?
Put ketchup on his crumpets? He's flaming
red and glaring at you with a pair of death
rays, you jerk.

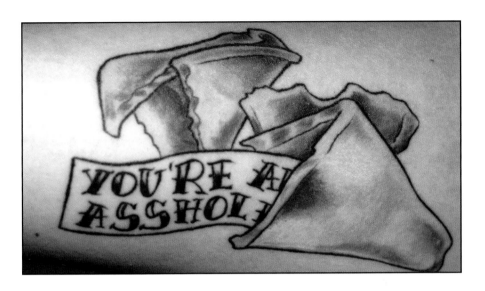

Can someone print these up and make a million dollars, please?

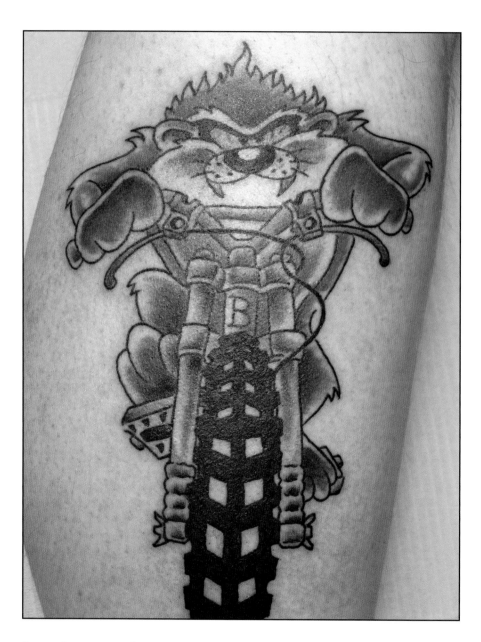

Attention guys: Getting a Taz tattoo EVEN IF IT'S A JOKE is like a chick lighting her farts at a party.

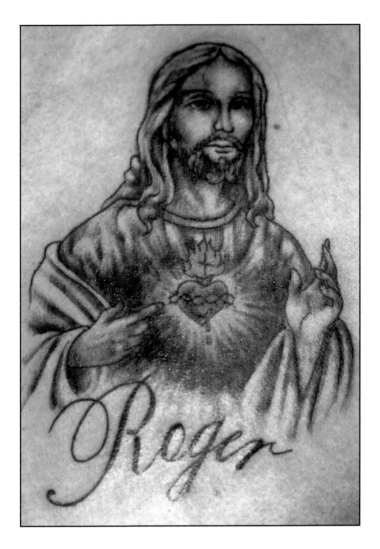

Roger looks a lot like JC.

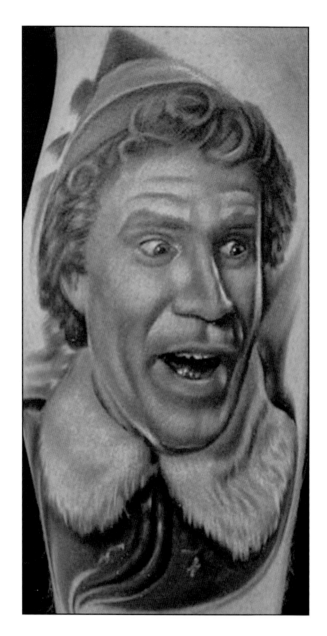

M'mmmkaaayyyyy . . .

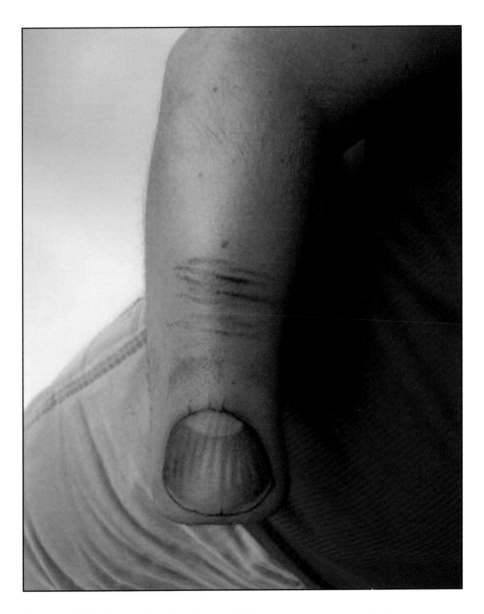

If you think I'm going to rip on this guy you are out of your fucking mind. He's basically the coolest person IN THE WORLD. We're so jealous that he gets to make this joke, we thought about cutting off a limb so we could have eternal laughs. Seriously, could you have a better attitude, guy? He makes the rest of us look like a bunch of crybabies.

Credits

1. Dan Plumley; 2. Ozzie Perez; 3. Marco at Lit Fuse Tattoo, Olympia, WA; 4. Jeff Leiber@ FC West Custom Tattoos; 5. Phantom Creep at Phantom Tattoo; 6. Cathy Johnson, Providence, RI. Studio is Regeneration Tattoo, Boston, MA; 7. Marco at Lit Fuse Tattoo; 8. Baker @ East Coast Tattoo Co.; 9. Adam Lauricella @ Graceland Tattoo, Wappingers Falls, NY; 10. Steve Morris at Bodyworks Tattoo Studio in Penn Hills, PA; 11. Mike DeVries; 12. Jason Bishop; 13. Pooh Bear @ Atomic Tattoos; 14. Jay Edward Worley; 15. Mike Tidwell, Obscurities Tattoo; 16. Joseph @ Visual Orgasm, Singapore; 17. Marco at Lit Fuse Tattoo; 18. Brandon; 19. Leif McHatton at Studio 13 Tattoos, Cocoa Beach, FL; 20. Sage O'Connell (Urban Art Tattoo); 21. Jessi Manuel @ Wild Bill's Tatttoo in Roseville, CA; 22. Courtesy of Beck Daniels. Tattoo by Mike "Chimp" Rinna at Art & Soul Tattoo; 23. Greg "Grease" Lehman; 24. Tattoo Andy; 25. Marco at Lit Fuse Tattoo; 26. Jason Stein; 27. Anonymous; 28. Aviva; 29. Coby (on him); 30. Cory Ferguson at Enlightened Art, Oakville, Ontario, Canada; 31. Marco at Lit Fuse Tattoo; 32. Marco at Lit Fuse Tattoo; 33. Courtesy of Tammy Perry. Tattoo by Josh Hughbank, Guilt by Association, Denver, CO; 34. Marco at Lit Fuse Tattoo; 35. Courtesy of Erin Oly. Tattoo by Stacie Jascott at Lit Fuse Tattoo; 36. Courtesy of Dave Ehrlich. Tattoo by Jeff Rassier from Primal Urge Studio in San Francisco, CA; 37. DTM at Amazing Grace Tattoo; 38. Jason Bishop; 39. Mike Tidwell, Obscurities Tattoo; 40. Ben from Ben Around Tattoos, Charlottesville, VA; 41. Marco at Lit Fuse Tattoo; 42. Phantom Creep at Phantom Tattoo; 43. Nick Whybrow at Immortal Ink Tattoo, Essex, UK; 44. Dave Sanchez @ Yer Cheatin Hearts Tattoos; 45. Jose Luera @ Wild Bill's Tattoo in Roseville, CA; 46. Courtesy of Erik Seaholm. Tattoo by Henry Lewis at Everlasting Tattoo, San Francisco, CA; 47. Leif McHatton at Studio 13 Tattoos, Cocoa Beach, FL; 48. Christina Sparrow; 49. Paul Acker; 50. DTM at Amazing Grace Tattoo; 51. Christina Sparrow; 52. Tony Uno, Inktown Tattoo; 53. Terry at Morning Glory Tattoo; 54. Kyle Cotterman; 55. Courtesy of Chris Payne. Ben Miller, artist, at Ben Around Tattoo, 56. Baker @ East Coast Tattoo Co.; 57. Stacie Jascott at Lit Fuse Tattoo; 58. Mike Tidwell, Obscurities Tattoo; 59. Wade Johnson at Karmic Tattoos; 60. Justin McCrocklin. By Matt Stines at No Regrets Tattoos; 61. Tattoo by EGO. Collector: Paul "the Viking." Studio: Emerald City Tattoo, Seattle, WA; 62. Gary Loco at Loco Tattoos; 63. Jason Stein; 64. Dan Hazelton, WI; 65. Baker @ East Coast Tattoo Co.; 66. Jimmy Bonehead; 67. Danny War @ Wild Bill's Tattoo in Roseville, CA; 68. Tattoo Andy; 69. Shawn Carrier at The Ink Spot, Ottowa, Ontario, Canada (Tattoo is on Chris Barton); 70. Cathy Johnson, Providence, RI. Studio is Regeneration Tattoo, Boston, MA; 71. Carter Moore @ Immortal Canvas; 72. Tony

Styles; 73. Baker @ East Coast Tattoos; 74. Wade Johnson at Karmic Tattoos; 75. K @ The Voodoo Needle; 76. Kyle Cotterman; 77. Hommie Vande @ Fine line Tattoo, Netherlands; 78. Nolan Ramey PDX, Oregon (on him); 79. GHOST; 80. Steve Nesbit at Powerhouse Tattoo Studio in New Zealand. Tattoo is on Mark Harris, New Zealand; 81. Chris Hornus @ Consolidated Ink & Steel; 82. Roscoe at Johnson Tattoo Studio; 83. Mike DeVries & Mike De Masi, Encino, CA; 84. Erik Reith at Seventh Son Tattoo; 85. Cindy Ronquillo (on her) done by Johnny Von Pezo of Ground Zero Tattoo; 86. Larry Brogan at Tattoo City, Lockport, IL; 87. Jason Robert Skidmore aka Jellybean (on him) by Derrick Allan; 88. Jason Robert Skidmore aka Jellybean (on him) by Derrick Allan ; 89. Kandi Everett @ China Sea Tattoo, photo by Shuzo Umoto; 90. Courtesy of Tammy Perry. Tattoo by Josh Hughbank, Guilt by Association, Denver, CO; 91. Courtesy of King Ferry, owner of Tattoo Palace, Amsterdam. Artist is Aiden from Bulgaria. 92. Doz; 93. Courtesy of Matthew Grunau. Tattoo by Mez Love @ Tainted Hearts Custom Ink, Greeley, CO; 94. Scott Holland @ Permanent Expressions, Richville, UT; 95. Scott Holland @ Permanent Expressions, Richville, UT; 96. Jamie Taete (photographer); 97. Dan Henk; 98. Johnny Andres at New Addiction Tattoos; 99. Tim Jordan at Optic Nerve Arts Tattoo Studio, Portland, OR; 100. Mohawk Matt (on him) by Tony at PTC; 101. Photo taken by Rick; 102. Mike Lowe; 103. Nikko Hurtado; 104. Larry Brogan at Tattoo City, Lockport, IL; 105. Nikko Hurtado; 106. Nikko Hurtado; 107. Nikko Hurtado; 108. Robert Warden, Permanent Expressions Tattoo, WV; 109. Tattoo is on Tommy Doxey. The artist is BT at Splash of Color in East Lansing, MI; 110. Marco at Lit Fuse Tattoo; 111. Johnny Andres at New Addiction Tattoos; 112. Chris Sink; 113. Bob Tyrrell; 114. Mark Hamilton @ Stinger Tattoo, Newmarket, Ontario, Canada; 115. Courtesy of Tom Hefner. Tattoo by Wayne Tudor at Ink Link Tattoos, Charlotte, NC; 116. Elana Barclay De Tolly; 117. Brad Bako at Fat Ink Tattoo; 118. Matt Griffith; 119. Brian Ricci. Artist is Adam Laurecella @ Graceland Tattoo; 120. Damien at Alien Arts; 121. Dan Hazelton, WI; 122. Justin McCrocklin by Matt Stines @ No Regrets Tattoos; 123. Courtesy of Megan Zoeller. Tattoo by Don Kizzee at Metamorphosis Body Modifications; 124. Jaystats Ireland; 125. Jason Stein; 126. Nikko Hurtado; 127. Brad Bako at Fat Ink Tattoo.

About the Authors

Aviva Yael

is a writer. She lives in New York City.

P.M. Chen

is a part-time basket-weaver, writer, and three-time silver medalist in the luge. He lives in Brooklyn, NY with his pet fish and six cats.